IMAGES
of America

SAGINAW

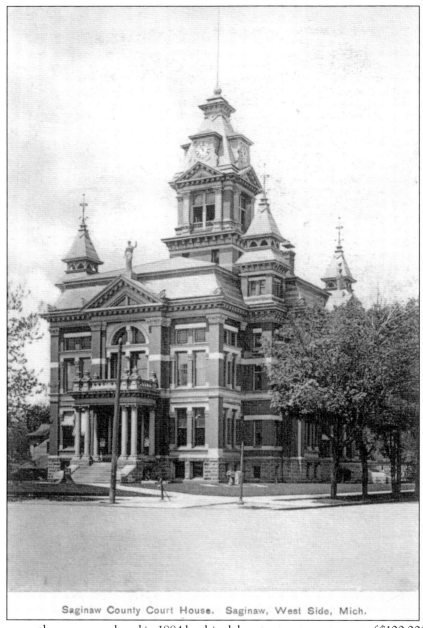

Saginaw County Court House. Saginaw, West Side, Mich.

A wooden courthouse was replaced in 1884 by this elaborate structure at a cost of $100,000. Above each of the building's four entrances was a statue of the Goddess of Law and Justice. The statues were ordered from a New York firm and painted to look like marble, but they were actually made of more than 500 pounds of hollow pressed zinc. (Author's collection.)

ON THE COVER: Taken on July 5, 1941, this image gives a view of the interior lobby of the Second National Bank, which was the tallest building in downtown Saginaw. Located at the corner of East Genesee Street and Washington Avenue, it was as impressive inside as out with its marble pillars and crystal light fixtures. Note that the tellers were all male. (Author's collection.)

IMAGES
of America

SAGINAW

Roberta M. Morey

ARCADIA
PUBLISHING

Published by Arcadia Publishing
Charleston, South Carolina

Printed in the United States of America

Library of Congress Control Number: 2010931936

For all general information, please contact Arcadia Publishing:
Telephone 843-853-2070
Fax 843-853-0044
E-mail sales@arcadiapublishing.com
For customer service and orders:
Toll-Free 1-888-313-2665

Visit us on the Internet at www.arcadiapublishing.com

This book is dedicated to Jacqueline, Spencer, Cassidy, Lara, and Morgan, my five wonderful grandchildren.

CONTENTS

ACKNOWLEDGMENTS

There are Saginaw books that highlight the founding fathers, street scenes, and early events. Therefore, when it was suggested that I create a title that took another direction, I decided to emphasize Saginaw people. I had so many people who helped with information and photographs that they must be acknowledged here. First, there is Robert Merritt, who allowed me to look through his collection of Saginaw postcards and borrow any that could be used in the book. Others who shared information, photographs, and more importantly, encouragement, are Sandy Schwan from the Castle Museum, Doug Aikenhead, Jean Beach, Jim Silk, Bob Pumford, Alex Gorashko, Mary Sue Barry, Tom Mudd, Stewart Franke, Bill Galarno, Patricia Stoppleworth, David Case, Marilyn Dust, Dr. David Silver, Bob Taylor, Dr. Norma Anderson, Hon. Terry Clark, Stevens Van Lines, Saginaw Public Schools, Hoyt Library, Emily Kennedy, and Brian d'Arcy James. With a limit of 70 words per image, there was so much more to be written about the people and images in the book. Hopefully, I have done justice to each of them. Finally, I need to thank the people at Arcadia Publishing for the assistance and help I received while working on this project.

INTRODUCTION

Not long ago, the historical society of Saginaw County's Castle Museum put together a display titled People Make the City. The display was of small, well-known shops and businesses in early Saginaw. There was a huckster's wagon, a trolley, and an area of photographs of Riverside Park. Saginaw people, structures, and events also make up the main theme of this book. It is not the landscape, the resources, or the rivers that made Saginaw special, but the people who used the resources to build a thriving city.

Archeologists have discovered indications of very early peoples living in the area. Later Native Americans settled along the banks of the rivers, which they used as a source of food and a means of travel. The Indians became familiar with the settlers who had moved into the area. From early reminiscences, tales were told of Indians walking to town with furs and deerskin moccasins to trade for flour, sugar, salt, and other foodstuffs; they also traded for guns and gunpowder. The Indian women picked wild fruits and sold them along with baskets they had made. Well-known Native American Shop-en-a-gons, a chief of the Chippewa, was always well received by the early settlers, who learned much of the Indian way of life from him.

Louis Campau came to the area in the early 1800s and opened a trading post at what is now Saginaw's west side. Campau was the person Gen. Louis Cass entrusted to build a council house for the meeting with the Indians to negotiate the Treaty of Saginaw. When the treaty was signed, the Native Americans had ceded large tracts of their land to the United States, and the government began to deed land to settlers.

There were the movers and shakers who came to the area, including Norman Little, Curtis Emerson, and Jesse Hoyt. But the big rush of people came when it was discovered that money and jobs could be had with the harvest of "green gold" (white pine trees). The lumberjack crews, known as the "Red Sash Brigade," were a rowdy bunch when they arrived by train in Saginaw after working in the woods during the winter months.

With sawmills flourishing along the Saginaw River, more workers were needed in the growing lumber industry. Along came Swedish, German, Polish, Irish, and French-Canadian immigrants. Many Germans settled in Saginaw, while Bay City had a major settlement of Poles.

When the "never-ending supply" of lumber ended, the cutover land was used for a new crop—sugar beets. Germans from Russia who were successfully raising the crop in the Western states were encouraged to come to the Saginaw Valley to work in the beet fields. Migrant workers from Mexico arrived to help plant and harvest crops. Many of the workers settled here permanently with their families. Some worked in other industries and enrolled their children in the city's schools.

There was always something new on the horizon to encourage people to come to Saginaw. The coal mines and the salt industry were important for a while. However, the big change came with the automobile industry. Factories were built and workers came from the South. Saginaw's African American population settled on the east side of Saginaw to take jobs in the foundries.

The growing population of immigrants caused a need for more schools. Both East Saginaw and Saginaw City had their own school systems before the two Saginaws were consolidated.

Saginaw had its share of disasters to overcome during its early days. Floods were a major problem, as was the huge fire of 1893, which was caused by sawdust, burning embers, and high winds. A major portion of East Saginaw burned in the blaze, all except St. Mary's hospital, which was saved when water was carried to the roof to douse the embers. Another casualty of the 1893 fire was the soap factory of Henry Passolt on South Baum Street. Passolt rebuilt the business, keeping his soap recipe a secret. He died in 1914 before it could be revealed.

The early 1900s to the 1920s saw the development of the parks system. The trolleys and interurbans were always filled, carrying passengers to work during the week and to Riverside Park on weekends. One of Saginaw's oldest dry cleaners was founded in the 1920s and named Goodwill because the partners had no money but plenty of goodwill.

The 1930s brought more changes, as the Depression did not bypass Saginaw. People were out of work. Shanties were built to house families, and the makeshift housing area was dubbed "Phoenixville" after Mayor George Phoenix. Some families opted to live on the river in houseboats. These residences could be seen on the Saginaw River until the 1960s, when they were outlawed. If there happened to be a lot available in the city, the houseboat was rolled on logs out of the river and on to the land.

When World War II came along, Saginaw's patriotism ran high. Boys of 17 and 18 years enlisted; many of them left high school to serve. Housewives whose husbands had been drafted went to work in the factories. Automobile plants converted to make tanks, guns, and other essentials needed to win the war. Saginaw had its share of heroes during World War II. Some were captured and became German or Japanese prisoners of war, while others were war casualties. German prisoners of war were housed in the Saginaw Valley at the Tri-City Airport.

Rationing was a way of life during the war years. Saginaw County residents had four days to register for ration booklets to buy sugar during World War II. Only one family member had to sign up in the school district where the family lived, but government officials issued coupons for each family member. Everyone received a pound of sugar every two weeks for the first eight weeks of the program. Nearly 34,000 people signed up the first day, and the number of registrants equaled the county's population at the end of the four days. In 1943, the county rationing board housed 135,000 food-ration books in a cell at the Saginaw County Jail.

In 1949, the city gave up its corner water pumps when the Lake Huron water pipeline brought "the world's best water" to Saginaw homes. A weeklong festival was held to celebrate the event.

The 1950s and 1960s saw the school system grow and produce well-known writers, actors, painters, musicians, professors, businessmen, and physicians. Irma E. Eichhorn, who graduated from Arthur Hill High School in 1944, likely was Saginaw County's first Fulbright scholar. She received her appointment in 1952, when she was a graduate student in European studies at the University of Michigan. Dr. Eric C. Hanson, the 1966 valedictorian at Arthur Hill, was the first student from the school to earn a Rhodes Scholarship to study economics at Oxford University. He went on to earn bachelors and medical degrees from Harvard University, specializing in cardiology.

All in all, the people and events in Images of America *Saginaw* are to be reflected on with pride.

One

EARLY DAYS

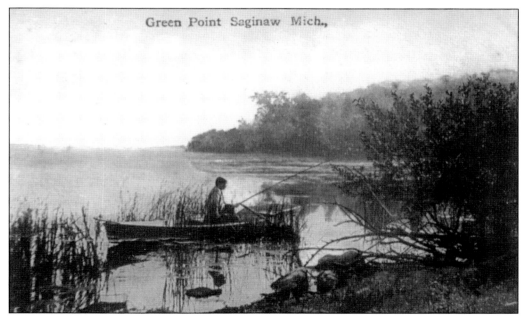

Green Point Saginaw Mich.,

The land and rivers of the Saginaw Valley were once the domain of Native American tribes. The Chippewa (also known as the Ojibwa) and the Ottawa selected the present site of Saginaw as their main camp. Another camp was located at a place known as O-Zhaw-wash-quah, or Green Point, where the Tittabawassee, Shiawassee, and the Saginaw Rivers joined. (Author's collection.)

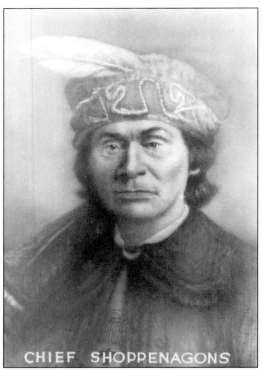

CHIEF SHOPPENAGONS

Chief Shop-en-a-gons, of the Chippewas, was born near Green Point, where as a child he learned to hunt and fish. He was a friend of the white settlers, who called him "Chief David Shop." He and his wife had five children. When the chief felt that deer were becoming scarce in the area, he moved with his family to Grayling, where he died in 1911. (Author's collection.)

Parkinson & Ziegler Deutsche Apotheke was a doctor's office and drugstore at 2348 South Michigan Avenue that served both English- and German-speaking citizens. Dr. F. Edmund Parkinson, a graduate of Saginaw Valley Medical College, had a separate entrance for his office. The delivery wagon used an umbrella that advertised the Krause Clothing Store, also a west-side business. (Author's collection.)

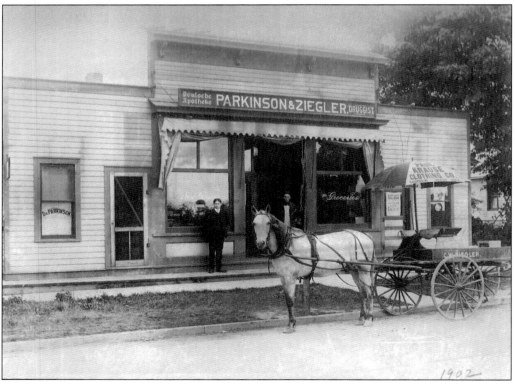

David Howell Jerome was born on November 17, 1829, in Detroit, Michigan. David and brother Tiff Jerome moved to Saginaw and owned one of the city's oldest hardware stores. The D.H. Jerome and Company store stood at Water (now Niagara) and Van Buren Streets. Republican David H. Jerome served as the colonel of the 23rd Michigan Infantry during the Civil War. He was elected governor of Michigan in 1881. (Author's collection.)

Charles L. Benjamin established a livery and undertaking business in 1880 at 308 South Hamilton Street at Cass Street. In 1882, this two-story brick building was erected on the same site. The stable had a harness room, haymow, and stalls for the horses. The undertaking parlor and casket showroom had a separate entrance. His son Mills I. Benjamin took over the business in 1909. (Author's collection.)

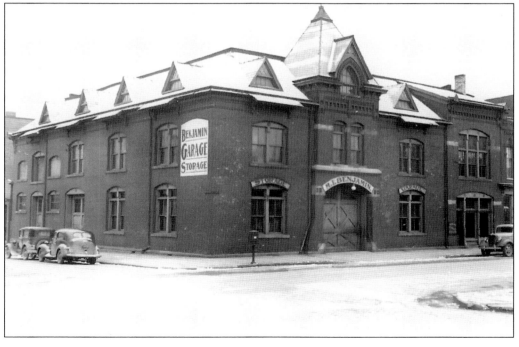

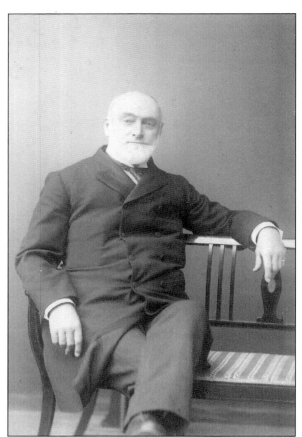

Henry C. Potter was born in Utica, New York, in 1823. He received a medical degree at Union College in Schenectady, New York. He married Sarah A. Farwell, daughter of a noted railroad contractor, and became a partner with his father-in-law in the contracting business, which brought him to the Saginaw Valley. In 1872, he was an organizer of the Savings Bank of East Saginaw. (Author's collection.)

The Pere Marquette Railroad Station, also known as the Potter Street Station, was the busiest station in Saginaw in its heyday. The sign on the trackside of the building reads, "East Saginaw." Henry Potter, with his father-in-law, Samuel Farwell, agreed to build the first section of the Flint & Pere Marquette Railroad, which was to run from Flint to Ludington, Michigan, a distance of 170 miles. (Author's collection.)

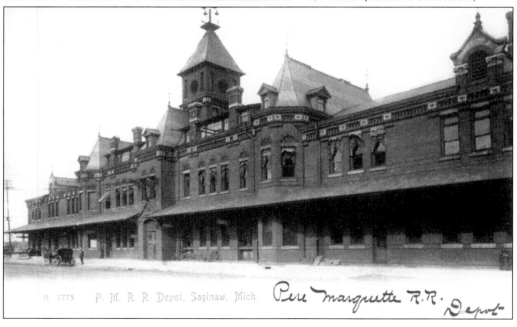

A 7773 P. M. R. R. Depot, Saginaw, Mich. Pere Marquette R.R. Depot

Aaron T. Bliss came to Saginaw in 1865 after hearing of the wealth and opportunities in the lumber industry. He worked in logging camps before acquiring enough capital to form A.T. Bliss and Company with his brother Dr. Lyman Bliss. Later, he helped organize the Citizen's National Bank of Saginaw. He served two terms as a Republican governor of Michigan, having been first elected in 1900. (Author's collection.)

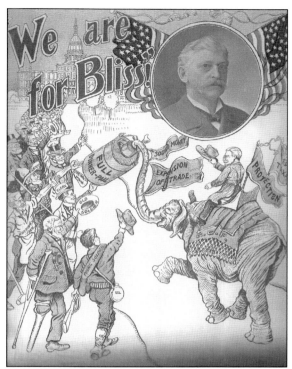

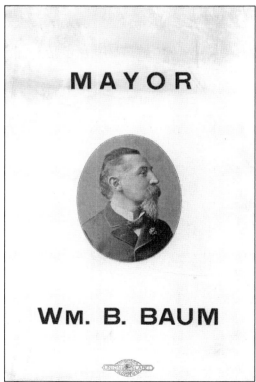

William B. Baum, a Democrat, was an insurance and real estate agent whose popular platform advocated low taxes. He was the city's mayor from 1896 to 1905 and from 1906 to 1907. In 1907, when the city council approved the construction of the auditorium at the corner of Janes and Water Streets, Mayor Baum disapproved of the site. In spite of him, it was built in 1908 on South Washington and Janes Street. (Author's collection.)

Arthur Hill's home in Saginaw was at the intersection of North Michigan and Remington Avenues. He and his wife, Aroline, had two children: son Harold and daughter Calla. After Aroline's death, Arthur married Louise Grout, who years later donated a substantial sum toward the cost of Arthur Hill High School's Memorial Stadium. The south wing addition to the Saginaw Art Museum occupies the home's site today. (Author's collection.)

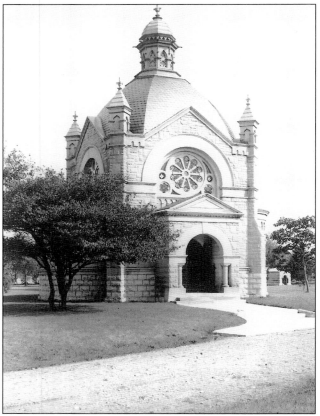

In 1881, there were a limited number of lots at Brady Hill, the city's oldest cemetery, which made it necessary for the city to purchase the Eaton farm at the southern city limits. A landscape artist was hired to draw up plans, known as the lawn system or park plan. The chapel and receiving vault were constructed in 1901 in the Byzantine style and surrounded with shrubs and evergreens. (Author's collection.)

The source of Saginaw's drinking water until 1947 was the corner pump. This one was on the corner of Court Street and Michigan Avenue. A chrome-plated pump used during the water festival earned a permanent pedestal in the water filtration plant. In 1956, city workers began removing the street-corner pumps, as they had waned in popularity after "the world's best water" arrived via the pipeline. (Author's collection.)

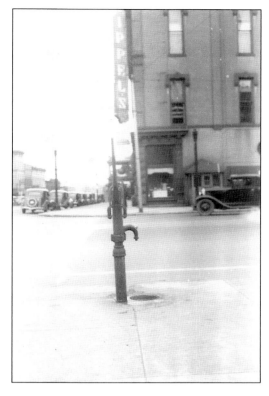

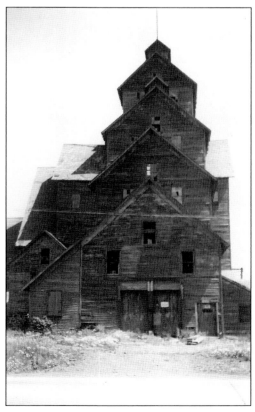

The Riverside Coal Company reported it mined 465,100 tons of coal in 1903. Saginaw Ice & Coal Company was its biggest stockholder, and James H. Malcolm was president. In 1908, the three consolidated coal company mines—Chappell and Fordney, Pere Marquette No. 2, and Standard No. 2—were mined out and closed. (Author's collection.)

City ordinances were pretty stern about the operation of interurbans and streetcars. Whoever held the streetcar franchise had to be careful when it came to hiring employees. Only sober and prudent agents, conductors, and drivers were hired to take charge of the cars while on the road. (Author's collection.)

Saginaw brick workers stand in front of a wall of bricks. Clay is the main raw material in the manufacture of bricks, and the clay for these bricks came from two sources: clayey sediments laid down in glacial lakes and shale bedrock. Saginaw had an abundance of this material for brick making. In 1860, ex-mayor Youmans owned a farm and brickyard that manufactured two million bricks. (Author's collection.)

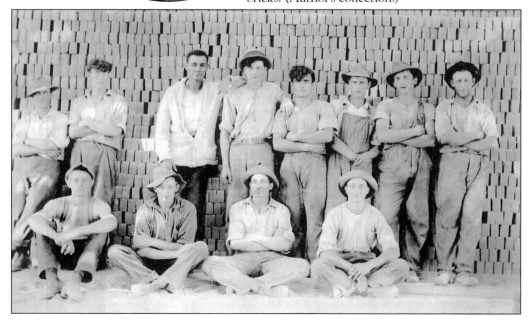

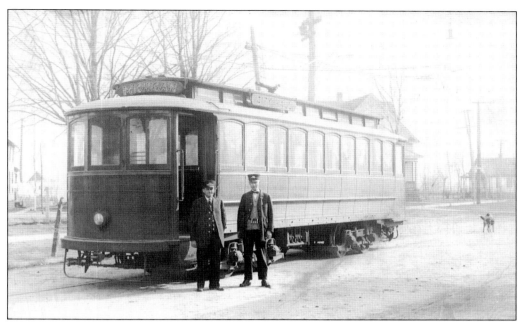

To Isaac Bearinger is due the honor of establishing the first electric interurban line running out of Saginaw (1894). He largely financed the building of this independent electric line from Saginaw to Bay City via the west side of the Saginaw River. The Saginaw Valley Traction Company bought the line in 1898. Track plows were tested in 1904 when a foot of snow fell. (Author's collection.)

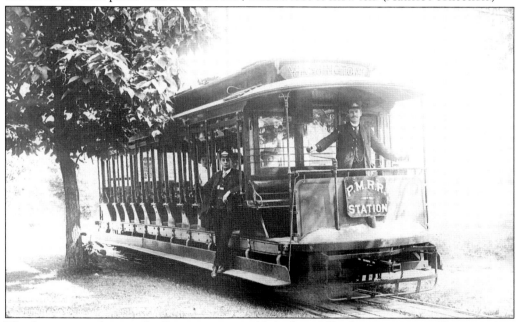

The first street railway in the Saginaws was established in 1863, when some men of Saginaw City organized the Saginaw City Street Railway Company with a capital of $30,000. The line traveled 2.5 miles. East Saginaw developed its own line in 1864 with a capital of $60,000. In the summer, a streetcar would squirt water on the pavement to keep the dust down. (Author's collection.)

The Butman-Fish Library on the west side of the city at the corner of Harrison and Hancock Streets was a gift from the wife of lumberman Myron Butman and their daughter Mary P. Fish. Erected in 1915, it housed the Indian artifacts of Fred Dustin and some of the books from Norman Little's original 1837 library. (Author's collection.)

Missing today from the roof is the G.A. Alderton and Company sign. Established in 1872, this company was the oldest grocery house in the Saginaw Valley in 1912. Incorporated in 1900 under the control of four Alderton family members, the three-story building at the corner of Cass and Niagara Streets housed offices and storerooms. The company dealt in groceries, notions, and candies. (Author's collection.)

310 South Jefferson

Jefferson Avenue Methodist Church

Saginaw, Michigan 48607

Jefferson Avenue Methodist Church was organized in 1852, and ground was broken on this Gothic Revival church in 1867. Originally, the building had a steeple rising to 162 feet, higher than any other structure in the city. It was toppled by a storm in 1896. The current steeple was constructed in 1987. In 2008, the church was renamed Grace United Methodist Church. (Courtesy of Robert Merritt.)

St. John's Episcopal Church, organized in 1851, was the third church society formed in the Saginaw Valley. During the early years, services were held in the old schoolhouse at Court and Fayette Streets and also in the old courthouse. The erection of the present church, on the corner of Court and Hancock Streets, began in 1883, and a parish house and rectory were built in 1887. (Author's collection.)

19

Since 1929, the magnificent Saginaw Water Works has served the community well. A Chicago architect designed the facility to be not only beautiful, but functional as well. The large central tower dominating the Gothic structure encloses a steel water tank and is surrounded by a group of interconnected structures. Stone carvings dealing with the history of the site are on the north and east faces of the building. (Author's collection.)

This building, which remains at the entrance of Forest Lawn Cemetery, was constructed in 1913 as a public-service building. The sturdy brick structure with an Art Deco interior contained a sexton's office and restrooms. It was used as a trolley station in early days, and today it houses records of the three city cemeteries. (Author's collection.)

The Schuch Hotel was established in 1868, three years after the close of the Civil War. Originally known as the Brockway House, it was built by Lew Brockway. John Schuch became the proprietor of the hotel and filled it with his collections of memorabilia of Michigan. As president of the Michigan State Historical Society, Schuch labored to display and preserve memories of early Saginaw. (Author's collection.)

The Saginaw Club was organized on April 18, 1889. Washington Avenue was the chosen site for the clubhouse. Membership was limited to 350 in the early years, but in 1913 the 150 members established a New Year's Day tradition when they toasted the office of the president of the United States. That year, lawyer Benton Hanchett toasted the office and paid tribute to outgoing president William H. Taft. (Author's collection.)

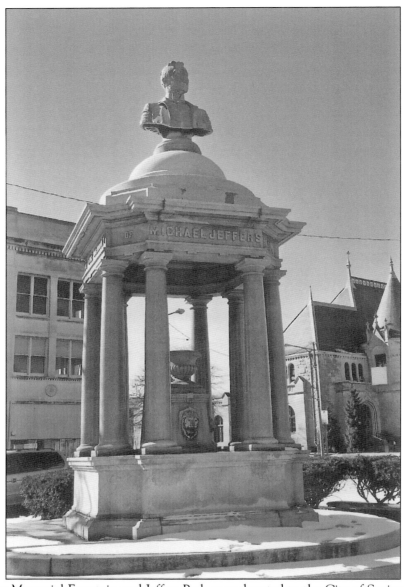

The Jeffers Memorial Fountain and Jeffers Park were donated to the City of Saginaw in 1905 by John Jeffers and his niece Elizabeth Champe. It was dedicated a year later as a memorial to Jeffers' brother, real estate developer and 50-year city resident Michael Jeffers, who died in 1904. Michael was an East Saginaw City councilman and a member of the Saginaw Board of Water Commissioners and the Saginaw County Board of Supervisors. A four-foot-tall bronze bust of Michael sits atop the granite fountain, and water flowed from four 18-inch lion's head statues. After its dedication in 1906, the fountain provided cold water year-round to passersby, who, for its first five years in operation, sipped from a communal tin cup. Between 1913 and 1919, the tin cups were outlawed by the health department. Jeffers Park is located on a small triangle of land bounded by South Warren Avenue, Federal Street, and East Genesee Street and encompasses half an acre. With its grassy areas, walkways, and attractive plantings, the area was like a central park for the city. (Author's collection.)

The seven-story Benjamin Franklin Hotel, once the Kirby office building, was Saginaw's tallest building when it opened in 1915. The hostelry, at 113 South Franklin Street, had marble walls in the lobby and mahogany furniture in its 125 rooms. For a time, occupancy flourished, but by the 1960s the hotel suffered a number of robberies and fires. Saginaw bought the building in 1976 and demolished it. (Author's collection.)

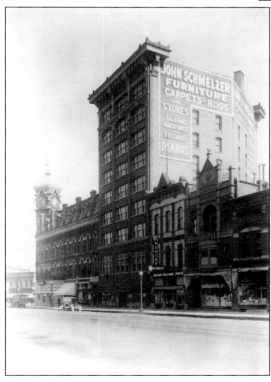

In 1912, John Schmelzer constructed this nine-story building at 511 East Genesee Street. The fireproof building had entrances on both Genesee and Lapeer Avenue, a sprinkler system, electric passenger and freight elevators, and a packing and handling department. The business specialized in furniture, home furnishings, floor coverings, and appliances. The business closed in 1961. (Author's collection.)

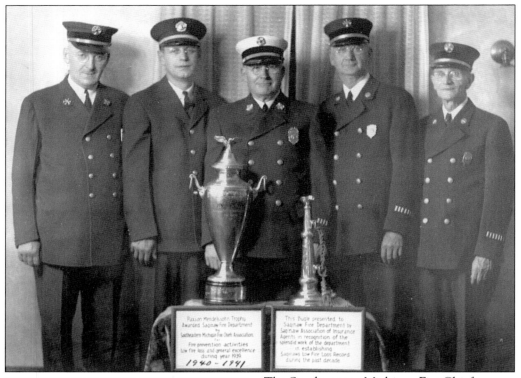

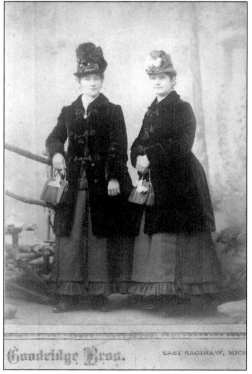

The Southeastern Michigan Fire Chiefs Association in Detroit awarded the Paxson Mendelssohn Trophy to the Saginaw Fire Department and Chief Frank W. Bender Jr. The ranking officers are, from left to right, Second Asst. Chief William C. McManmom, Inspector Alfred R. Borm, Chief Frank W. Bender Jr., First Asst. Chief Frank Mell, and Third Asst. Chief Daniel J. Presley. Also awarded was the Bugle Trophy from the Association of Insurance Agents. (Author's collection.)

African American brothers Glenalvin, Wallace, and William Goodridge came to East Saginaw from York, Pennsylvania, where they were established photographers. Although portraiture was a significant part of their market, such as the 1880s picture of the sisters seen here, they became well known for their landscape photography. Their landscape work tells the story of Saginaw's early days. They became the photographers of choice for Saginaw business, social, and civic events. (Author's collection.)

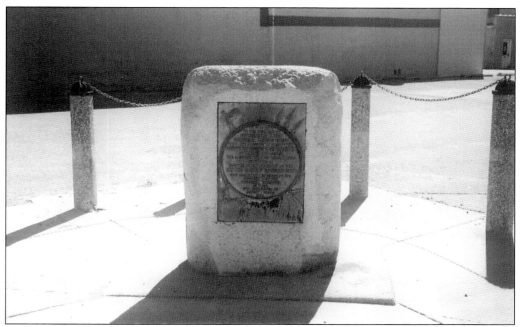

On the corner of Hamilton and Cass Streets is a treaty marker. The tablet on the marker was erected by the Daughters of the American Revolution and the City Federation of Women's Clubs in 1916. The spot commemorates the date of September 27, 1819, when Gen. Lewis Cass made a treaty with the Chippewa Indians that ceded a large part of their lands to the government. (Author's collection.)

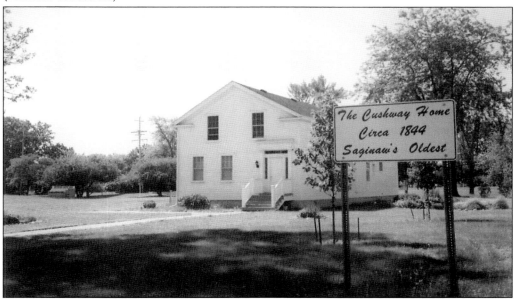

The Cushway House is the oldest surviving residence in Saginaw County and was erected in 1844 by blacksmith Benjamin Cushway. Originally, it was situated in the area of Court and Hamilton Streets. It was moved in 1867 and again in 2001. Along with the French-Canadian Cushways, the home was owned by the German Vogts and the Italian Nacarato families. (Author's collection.)

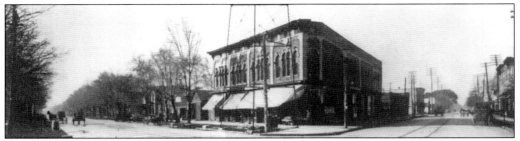

This 1905 image depicts the Strobel Brothers General Store, which was located at the southwest corner of Michigan and Gratiot Avenues. Strobel Brothers was one of the last of Saginaw's major general stores. The huge tower out front was one of the tall light towers the west side had for years as substitutes for streetlights. (Author's collection.)

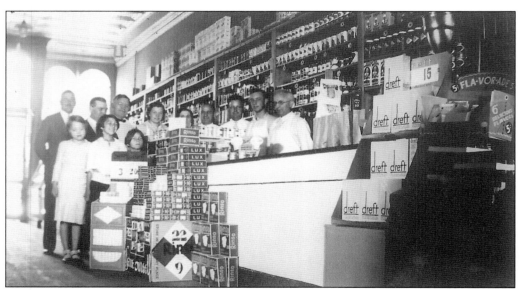

This is an interior view, taken in 1934, of the Strobel Brothers General Store. In the front are three unidentified children; in the second row are, from left to right, two salesmen, Louis Strobel, clerk Margarete Stier, clerk Isbel Easton, Ben Strobel, Carlyle Strobel, Wallace Strobel, and Henry Strobel. In addition to groceries, the store had a shoe and a clothing department. (Author's collection.)

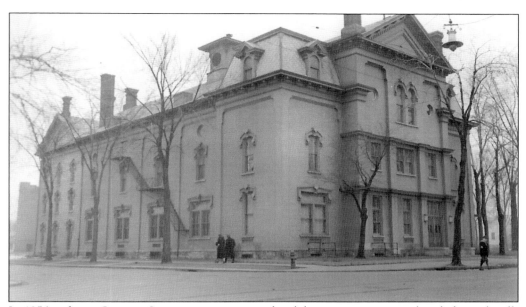

In 1856, a dozen German Saginaw men organized a club to improve spiritual and physical well-being for its members. Germania Hall, built in 1877 and located on Third and Lapeer Streets, also offered the first kindergarten in the city. When the club moved to the west side it became the Germania Town and Country Club. In 2010, with dwindling membership, the club closed its doors after 154 years. (Author's collection.)

On April 24, 1908, these four dignitaries rode to the laying of the Saginaw Auditorium cornerstone. In the carriage are, from left to right, *Labor Exponent* editor Edward Hartwick, Congressman William S. Linton, Mayor William B. Baum, and Wellington R. Burt, who was the main benefactor of the building. (Author's collection.)

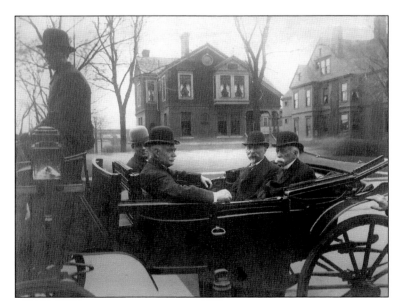

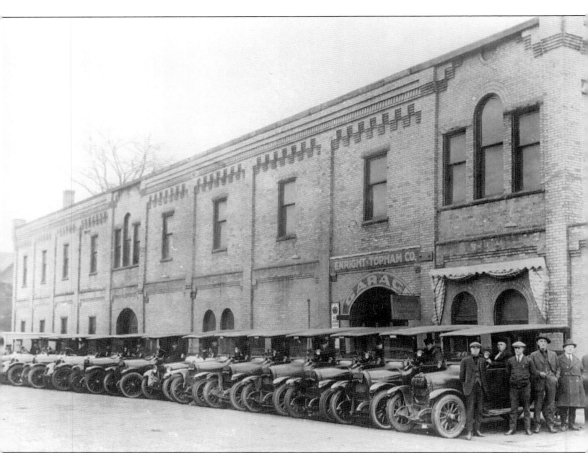

These are not Saginaw's first taxicabs, but they represent the first real fleet. This took place in 1922, soon after the Bartow & Enright and William B. Topham interests merged to form the Enright-Topham Company. Both firms had used automobile taxicabs earlier, back to 1913, but this was the first time all had been of the same make and style. These 13 cabs, lined up along the 200 block North Baum Street, carried the Shaw name, but they were made by a Pontiac concern that later became Yellow Truck and Coach before becoming a part of General Motors. At the far left in the lineup is an ambulance. Standing are, from left to right, Bernard T. Topham Sr., Percy W. Topham, William B. (Barney) Topham, tire salesman Edward McGraw, and Saginaw tire supplier James E. Dwan; in the driver's seat of the first taxi is James True, who later became a deputy sheriff. (Author's collection.)

Two

THEATERS AND PLAYERS

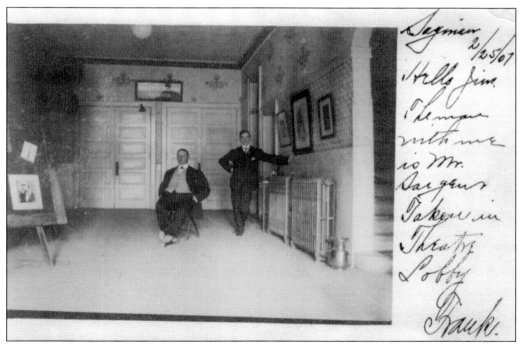

In 1907, this theater lobby could be the Dreamland (later the Mecca), the Family, the Bijou, or the Jeffers-Strand. These were the popular movie houses at the time. In the 1930s and 1940s, Saginaw moviegoers had their choice of 17 movie houses. The Temple Theater and the Court Theater, two of the original group, remain in operation today. (Courtesy of Michael Slasinski.)

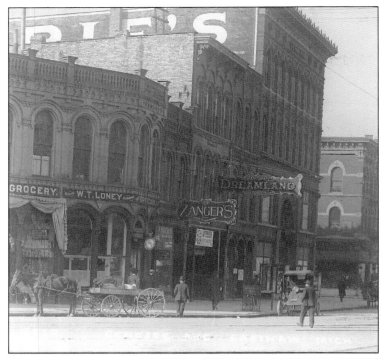

The Dreamland Theater stood on East Genesee Street between Baum and Jefferson Streets. When it opened in 1908, state-of-the-art technology was in place. There were double projectors and a stereopticon lantern for illustrated song slides. Lantern slides were the size of a postcard and made of two pieces of glass with tape around the edges. The slides served as a backdrop for vocalists. The Mecca Theater Company bought the theater in 1916. (Author's collection.)

The Jeffers, at 100 South Washington Avenue, opened in 1902. For years, it was one of Michigan's finest vaudeville houses. The theater changed hands several times until 1909, when W.S. Butterfield took control. In 1915, it became the Jeffers-Strand, showing only movies, but vaudeville returned the next year when the Franklin Theater opened for movies. The theater closed in 1927 when the Temple Theater opened. The building was demolished in 1972. (Author's collection.)

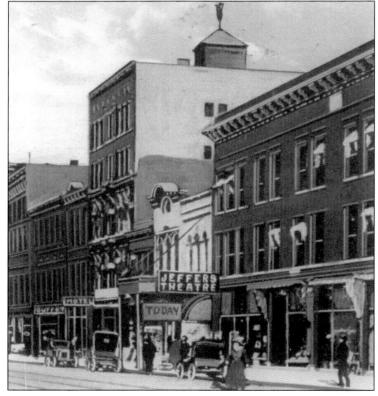

The Empire Theater, located at 417 East Genesee Street, was down the road from the Bijou but was not as elegant. Instead of a roof over its entrance, it had an awning. It opened in 1908 as a small, inexpensive neighborhood theater. Moviegoers would ride the streetcar to the theater, often stopping for a nickel ice cream treat after the show. (Author's collection.)

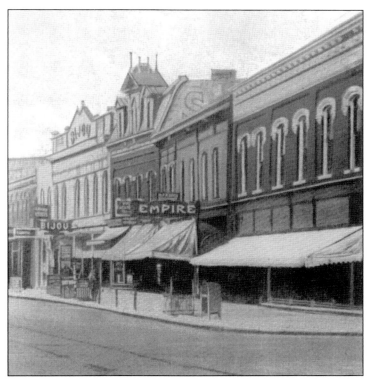

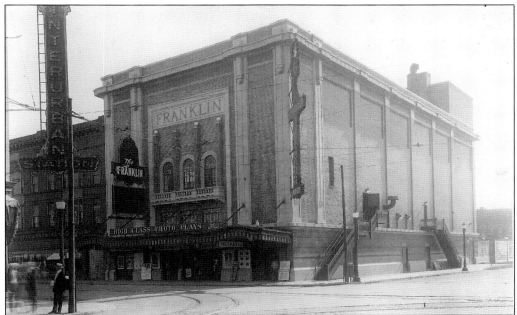

The Franklin Theater, at 132 South Franklin Street, opened in 1915 when vaudeville was king. A year later, the Butterfield Company, which owned the theater, switched to motion pictures. Declining business and heating concerns prompted owners to close the building in 1972. Jacobson's, Inc., acquired the property for parking in 1973. (Author's collection.)

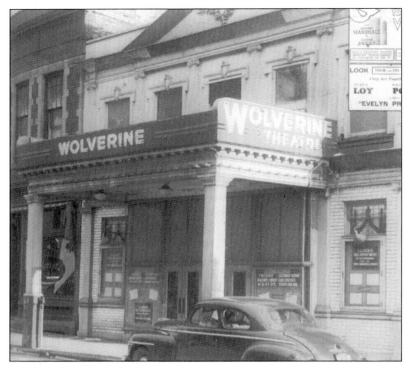

The Wolverine Theater, at 118 South Hamilton Street, was rated to be one of the prettiest of its kind in Michigan when it was built in 1911. It operated first as a vaudeville house and was converted to a movie theater in 1913. A glass screen that was thought to weigh 2,300 pounds was installed in the theater. (Courtesy of the Castle Museum.)

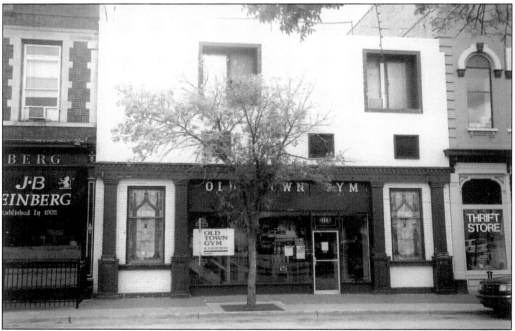

When the Wolverine Theater closed in the early 1950s, its building was empty until it opened as an art shop. The building that housed the Wolverine Theater still exists today in Old Town Saginaw on Hamilton Street. The art deco–style windows that earlier displayed movie posters remain on either side of the current occupant's doorway. (Author's collection.)

The North Side Theater, located at 2007 North Michigan Avenue, opened in 1926. In the 1940s, the admission price was 9¢, and Saturday morning serials were popular. The building was remodeled in 1951 as the New Roxy. In 1954, it became the World Playhouse, which played foreign films. This is a view of the small building after it closed in 1957. The Webster Leather Company was next door at 2005 North Michigan. (Author's collection.)

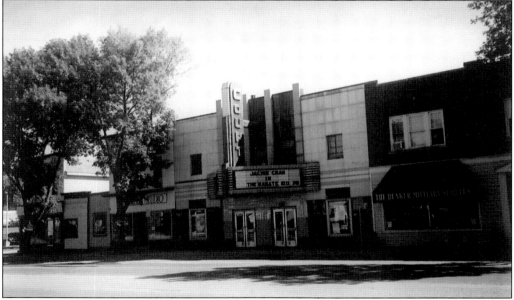

The Court Theater is still in business at 1216 Court Street. Frederick Witters built this air-conditioned art deco theater in 1938 for $20,000. It changed owners in 1957 and lasted only four months as the Guild. It reopened as the Court and closed again in the mid-1990s. Now it is owned by the Wehner brothers, who have restored the theater and show second-run films. (Author's collection.)

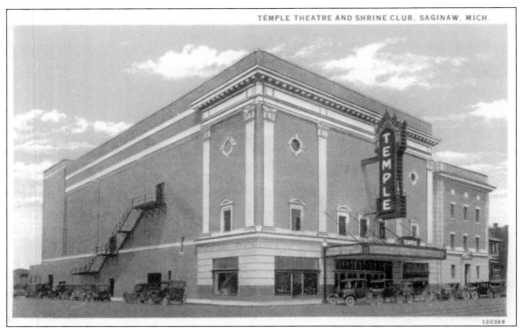

The Temple's beautiful marquee was installed at its completion. Inside the building were seats for 2,196 patrons. The usherettes were outfitted in gabardine wine-colored uniforms trimmed in gold. They wore white shirts and black ties and carried flashlights. They earned 25¢ an hour, working from 1:00 p.m. to 5:00 p.m. and coming back to work from 7:00 p.m. to 9:30 p.m. The ticket sellers sold upstairs seats for 55¢ and downstairs seats for 40¢. (Author's collection.)

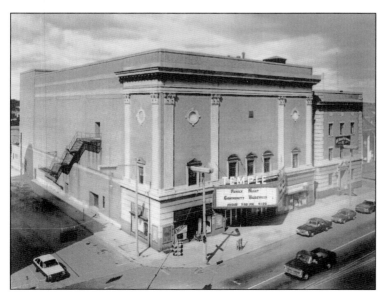

After closing in 1977, a number of groups cared for the Temple building, trying everything from country music to vintage films to keep it in operation. An organ club worked diligently to save the building. In early 2000, SSP Properties, headed by Dr. Samuel Shaheen, purchased the theater. After a costly renovation, the Temple was restored to its 1927 grandeur and reopened in 2003. (Author's collection.)

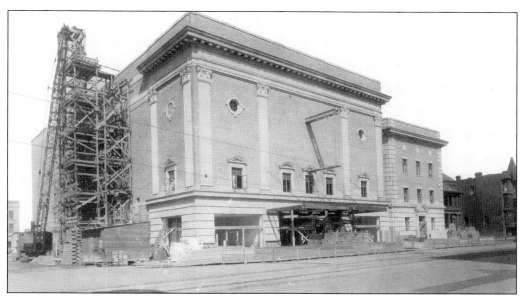

The Temple Theater is pictured under construction in the 1920s on Washington Avenue. It opened in 1927 as the largest theater in the state outside of Detroit. The Elf Khurafeh Shrine built the facility and its adjoining temple next to the East Saginaw Club. The theater featured a Barton organ with 11 ranks and 975 pipes. The organ was one of only 12 known to have been manufactured. Butterfield Theaters, Inc., leased the theater to show top-rated movies. (Courtesy of the Castle Museum.)

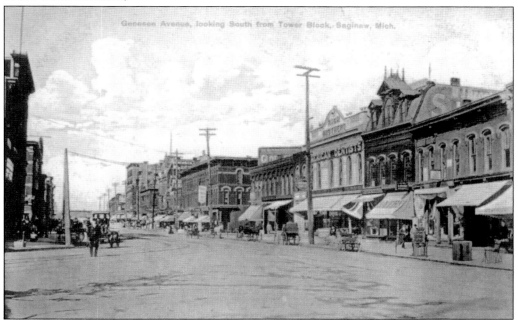

Isaac and Adolph Rich were owners of the building at 409 East Genesee Street starting in 1882. They leased their department store to an amusement company for use as one of Saginaw's first vaudeville houses. It became known as the Bijou when Col. Walter S. Butterfield bought the business. (Author's collection.)

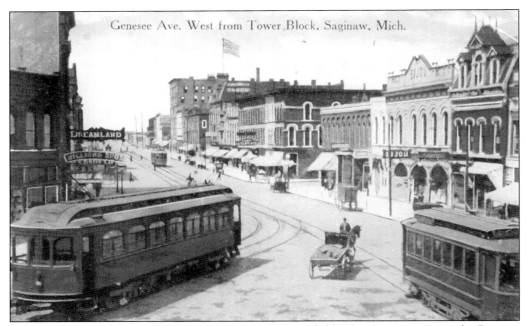

Genesee Ave. West from Tower Block, Saginaw, Mich.

After buying the business in 1909, Col. Walter S. Butterfield, a booking agent, put the Bijou at 409 East Genesee Street on an eight-town vaudeville circuit. The Bijou dropped vaudeville in 1911 and reopened as a movie house, the first in Saginaw, showing nothing but movies. Admission was 5¢. (Author's collection.)

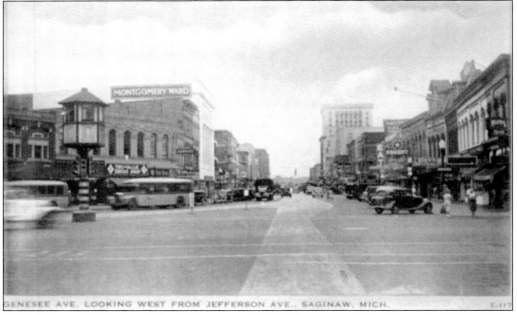

GENESEE AVE. LOOKING WEST FROM JEFFERSON AVE., SAGINAW, MICH.

In 1914, Butterfield enlarged the Bijou, renamed it the Regent, and brought vaudeville back. But bad business conditions forced him to shutter the theater in 1930, with plans to reopen it when economic conditions improved. In 1938, the revamped theater, now named the Center, opened showing double features Tuesdays through Fridays. (Author's collection.)

Robert William Armstrong, born in Saginaw on November 20, 1890, is familiar to old movie buffs for his rapid-fire vocal delivery in over 160 films. After moving west with his family and influenced by his uncle, playwright Paul Armstrong, he found he had a gift for acting. Armstrong's defining moment came when he was cast in the movie *King Kong*. He uttered the famous line, " 'Twas beauty killed the beast." (Author's collection.)

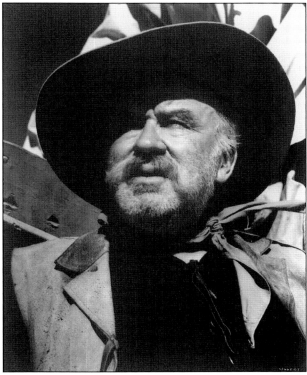

Harry Shannon (1890–1964) was born and educated in the public schools of Saginaw. After joining a traveling repertoire, his path led him to New York and Broadway. Success in vaudeville in 1910 made him a well-established actor in musical comedy and dramatic roles. He gained the attention of filmmakers and developed as an outstanding character actor. He appeared in *Citizen Kane* as Kane's father. Pictured is his portrayal in *The Marauders*. (Author's collection.)

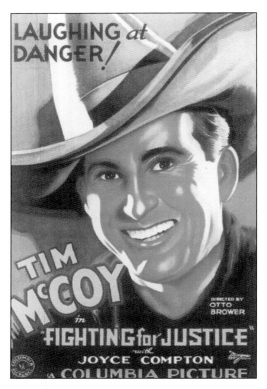

One of the great stars of early American Westerns, Tim McCoy was the son of an Irish soldier who later became police chief of Saginaw, where McCoy was born in 1891. While working on a Wyoming ranch, he became an excellent horseman. MGM signed him to a contract to star in a series of Westerns, and he rapidly rose to stardom. He occasionally toured with his own Wild West show. (Author's collection.)

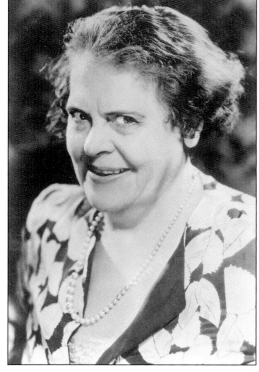

Marie Dressler is considered one of the greatest comediennes of her generation. She was born Leila Koerber in 1869 in Canada and came to Saginaw when her musician father took a job at the Academy of Music. As a child, she wrote and produced her own dramas. When her father disapproved of her productions, she threatened to go over to Boardwell's Opera House to dance on a barrel. (Author's collection.)

Three

BUSINESS

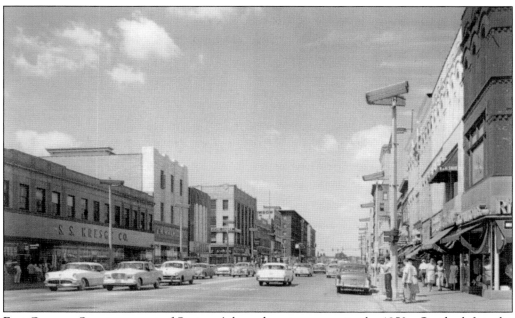

East Genesee Street was part of Saginaw's busy downtown area in the 1950s. On the left is the expanded Kresge Store, which opened in 1949 on the 300 block. Its expansion took in the former Seitner Department Store location. (Author's collection.)

Booth & Boyd Lumber Company was located on the corner of Holden and Baum Streets. George and Robert Boyd started the business, which specialized in building materials of all kinds. In 1909, an advertisement claimed that they were never out of what the customer needed. The business stocked white pine, yellow pine, and hemlock lumber to be used in sashes, door frames, and for interior finish. (Courtesy of Robert Merritt.)

NOT GUILTY.

NOT GUILTY OF NOT HAVING JUST WHAT YOU WANT. NO "JUST OUT" WITH US. WE CARRY AT ALL TIMES A LARGE AND WELL-ASSORTED STOCK OF WHITE PINE, YELLOW PINE AND HEMLOCK LUMBER, LATH AND SHINGLES. ALSO FENCE POSTS. NUFF SAID. OUR PRICES SPEAK FOR THEMSELVES. -:- -:- -:- -:- -:- -:-

BOOTH & BOYD LUMBER CO.

HOLDEN STREET, SAGINAW, MICH.

BOTH PHONES 355

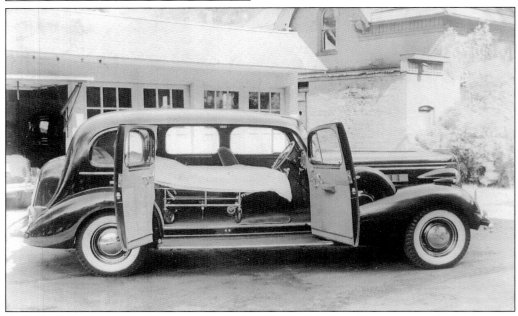

Swift Body & Equipment Company, located at Water and Hoyt Streets, advertised this sedan ambulance. The pictured Buick could easily be converted from a regular sedan into a sedan ambulance in less than three minutes. The car could also be used at a funeral for the family or bearers' car. Reasonable prices were offered for conversion and cots. The advertising card was sent in 1938. (Courtesy of Robert Merritt.)

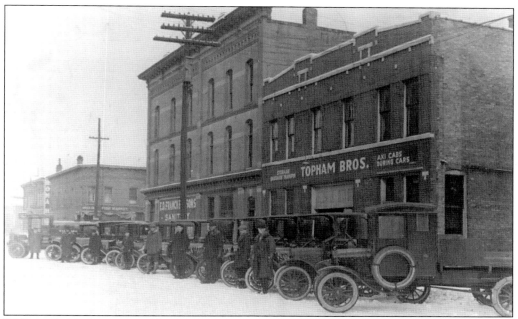

William B. Topham started his company in 1908 when he bought the Wright livery. In 1913, Topham sold his horses and bought a Model T, and his competitors followed his lead. Brothers Barney and Hanford Topham, who were Regatta-winning oarsmen, joined the business after their rowing days were over. After a brief absence in the early 1980s, the company returned as the Yellow and Checker Cab Company. (Author's collection.)

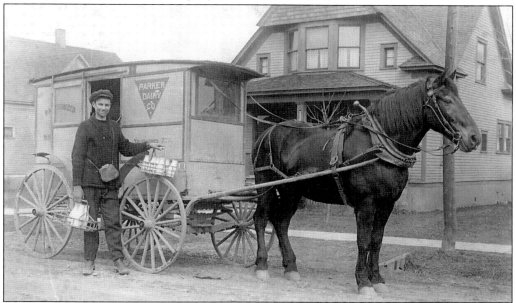

In 1905, Parker Dairy Company began delivering a high grade of pure milk and cream to the citizens of Saginaw from their sanitary milk depot located at 228 North Warren Avenue. Milk for infants and invalids was furnished from tuberculin-tested cows. Milkmen delivered fresh milk daily using horse-drawn carts. (Courtesy of Robert Merritt.)

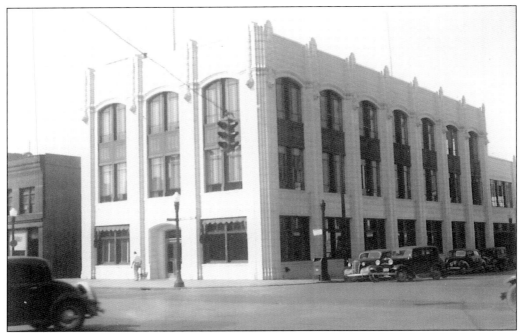

This beautiful Art Deco building on the corner of South Washington Avenue and Federal Street was the home of the *Saginaw News* until the structure was razed to make way for a larger and modern structure in 1960. For 50 years, the *Saginaw News* was in this larger building until another move was necessary in 2010 to smaller offices. (Author's collection.)

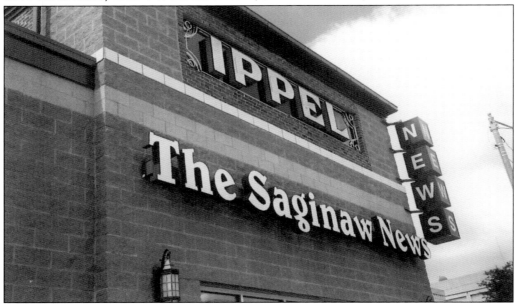

The new home of the *Saginaw News* is in the Ippel Building in Old Saginaw City. It is not the only business in this new structure, which is located on the corner of Court Street and Michigan Avenue. The Court Street Café takes up the front of the building that replaced the Merrill Building after a fire destroyed it in 2002. (Author's collection.)

The Bancroft Hotel opened on September 5, 1859. It had gaslights fueled by the hotel's own gas plant, steam heating, and two bathing rooms supplied with water from the Saginaw River. The structure was rebuilt in 1916. In 1954, the hotel's Flamingo Room was to make way for a new and larger dining room called the Log Mark Room. It was to memorialize the Saginaw Valley lumber industry. (Author's collection.)

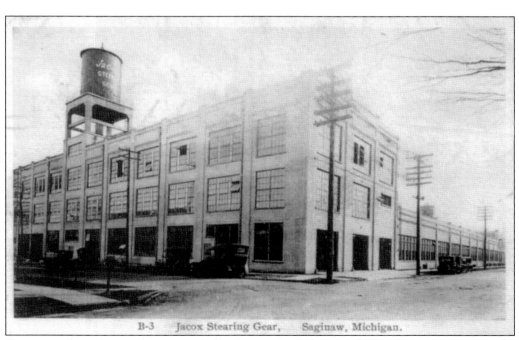

From manufacturing machines to grinding beet pulp, Jackson and Church grew to become the Saginaw Division of General Motors as Jacox Steering Gear. As Jackson-Church and Wilcox, it became one of the largest employers in the Saginaw Valley. The automobile industry dominated the area and gave it nearly 50 years of prosperity. (Courtesy of Robert Merritt.)

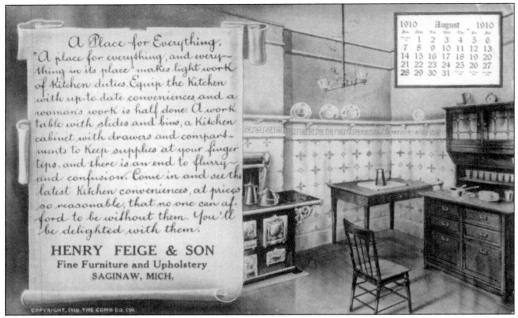

This advertising card for Feige's Furniture with a 1910 calendar depicts kitchen items for sale at the store. The Feige Company was the first furniture store in Michigan to convert from gaslight to electricity, to use truck delivery instead of horse and buggy, and the first to install a power elevator. (Author's collection.)

Englehardt Feige, a furniture manufacturer and carpenter, moved from Marion, New York, in 1854 to take advantage of Saginaw's flourishing lumber business. There was no furniture store in the area, so Feige designed, built, and sold his products directly to consumers. The large seven-story building at the Jefferson Avenue, Lapeer Avenue, and Genesee Street intersection was a downtown landmark for nearly 129 years. In 1983, the company moved to Saginaw Township. (Author's collection.)

Julius Liebermann, born to a shoemaker in Detroit, learned early to love leather. He left school in the seventh grade and became a traveling salesman. In 1893, he came to Saginaw and opened a store and a small manufacturing plant. From a shop in the Heavenrich Building to his own at 415 East Genesee Street, the luggage store branched out into a store carrying all kinds of leather articles. (Courtesy of Jean Beach.)

Julius Liebermann founded Liebermann Trunk Company in 1893. The store had several downtown Saginaw addresses before settling at 415 East Genesee Street. Liebermann died in 1953. Hiel M. Rockwell, Liebermann's son-in-law, started as a clerk and ran the business for 40 years until he died in 1979. Shown here with Liebermann are Hiel Rockwell Sr. and Hiel Rockwell Jr. (Courtesy of Jean Beach.)

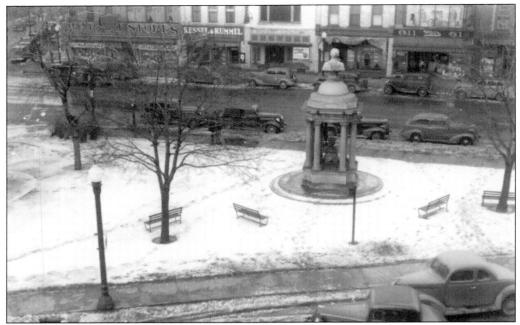

Along with other Saginaw businesses across from Jeffers Park on East Genesee Street was Walz Hardware. The store stocked everything from hammers to harnesses. George Walz founded the family business in 1869 to sell lumber supplies. A harness repair shop, tucked in the rear of the building, fixed leather goods well into the 1950s. The business was sold in 1969. (Author's collection.)

The Liebermann Trunk Company at 415 East Genesee Street and 111 North Jefferson Avenue was a trunk manufacturer and a dealer in luggage, leather goods, and gifts. It was the place to purchase anything made of leather, from a musical jewelry box to a set of luggage. If the customer desired, a shopper could have the item monogrammed. (Courtesy of Jean Beach.)

Morley Brothers employees dubbed it the Burma Road after its namesake that connected Burma with China. It was a second-story walkway over Water Street linking the Washington Avenue store to its Water Street warehouses. From the warehouses, ships at the Saginaw River dock were loaded with goods. Morley Brothers was the second-largest hardware company in the country. Workers demolished the 1939 walkway in 1969 to make way for a parking lot. (Author's collection.)

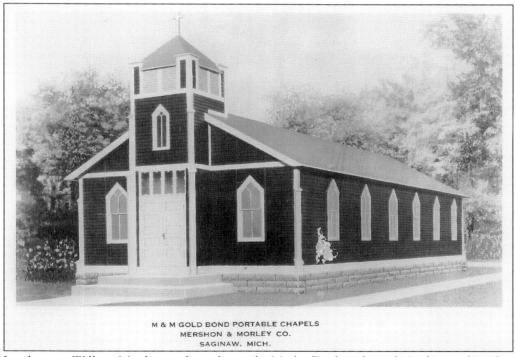

M & M GOLD BOND PORTABLE CHAPELS
MERSHON & MORLEY CO.
SAGINAW, MICH.

Lumberman William Mershon and merchants the Morley Brothers formed Mershon and Morley, a manufacturer of portable houses. Shown here is a popular portable church structure. Organizers of the Louisiana Purchase Exposition in Saint Louis, Missouri, offered a contract to the company to supply portable cottages for fairgoers. The units were to form a temporary village. In 1906, fifty portable housing units were shipped to Venezuela earthquake victims. (Author's collection.)

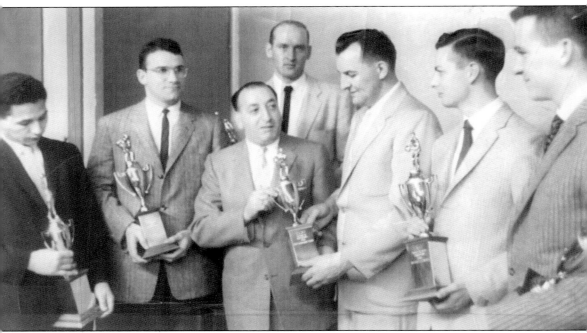

Edward Silk sponsored a Saginaw Amateur Basketball Federation winning team. They were awarded their trophies on March 28, 1958, at a banquet at the Bancroft Hotel. Pictured are, from left to right, Joe Vasquez, Howard Maturen, Silk, Fred Holnagel, Ted Kjolhede, Bernie Kalahar, and Sid Brady. In 1946, Ed founded Edward's Men's Shop on Franklin Street in downtown Saginaw. The store was a hub of commerce and camaraderie. Soldiers returning to the area would come in to catch up on the news of friends and acquaintances. College students gathered at Ed's, where he was always willing to extend credit to them. Aside from being an astute businessman, Ed was known as a philanthropist. His generosity benefited schools, hospitals, and various organizations. He paid the tuition for many area students at Delta College. His success in business was due to his treating people well and offering exceptional customer service. Today, after nearly 60 years in business, the store remains in the competent hands of Eddie's sons Jim and Gary Silk. (Courtesy of Jim Silk.)

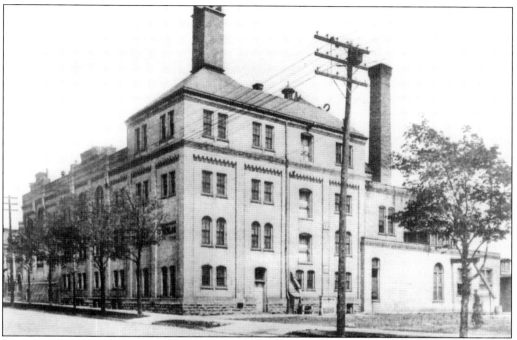

John G. Schemm started one of Saginaw's first breweries on the city's east side in 1865, but when fire gutted the operation he relocated to Saginaw City the following year. Schemm Brewery, on North Hamilton Street, was the first area brewery to make ale. In 1881, seven workers turned out more than 4,000 barrels of beer. The brewery closed during Prohibition. (Author's collection.)

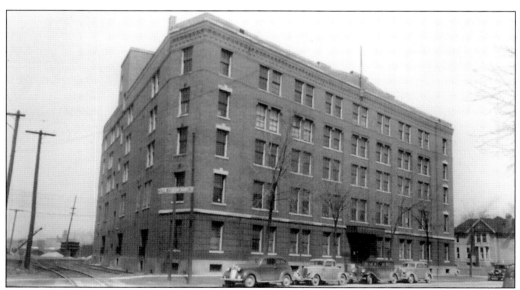

Symons Brothers & Company began in 1886 as a wholesale grocery business. Continual growth necessitated a large structure on South Washington Avenue between Millard and Thompson Streets. It was a five-story warehouse containing salesrooms and offices. It also had direct railroad connections with the Michigan Central and Grand Trunk Railways. (Author's collection.)

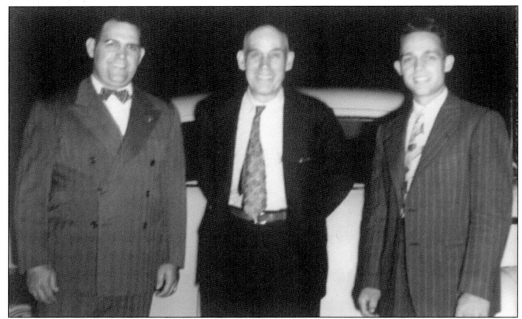

In 1930, Alfred Pumford and his son Fred earned less than 50¢ per day mining coal. Looking for a better opportunity for their families, they acquired a pick, shovel, and wheelbarrow and began digging Michigan basements. In 1938, after years of hard work, Alfred saw the potential to begin his own business and founded Alfred Pumford & Son. Pictured are, from left to right, Fred, Alfred Sr., and Alfred Jr. (Bud) Pumford. (Courtesy of Robert Pumford.)

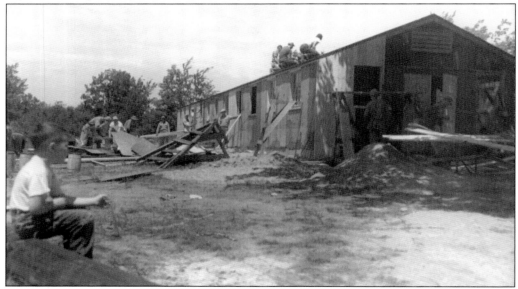

During World War II, German prisoners of war were housed in barracks at Tri-City Airport. When they were put on the Army's surplus list, the Pumford employees volunteered their time to rebuild the barracks at the Hartley Nature Center. Along with the workers on the roof is 18-year-old Bob Pumford, who later would serve for 15 years as the president of Pumford Construction. (Courtesy of Robert Pumford.)

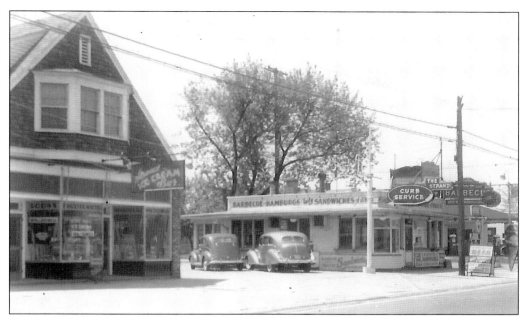

On the southeast corner of State and Bay Streets was the Strand Barbecue. It was a gathering place for the high school set; the popular saying was, "I'll meet you at the Strand." The Strand had its start in 1927, and in food industry history it was the first drive-in in the area. (Author's collection.)

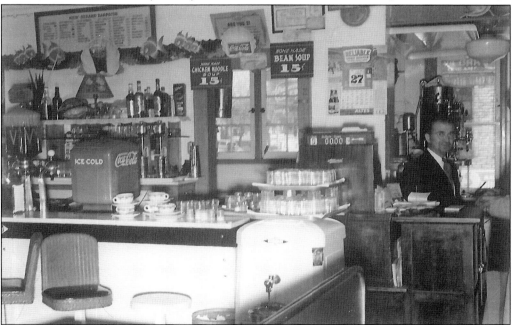

The owners of the Strand were John and Hattie Coenis. John is pictured here inside the restaurant, which also featured curb service. The Coenis family was proud be recognized as proprietors of a good, clean, orderly place noted for its tasty variety of menu items. Until it was sold in 1970 to make way for a Shell gas station, the Strand was a way of life for a generation of Saginaw's young people. (Author's collection.)

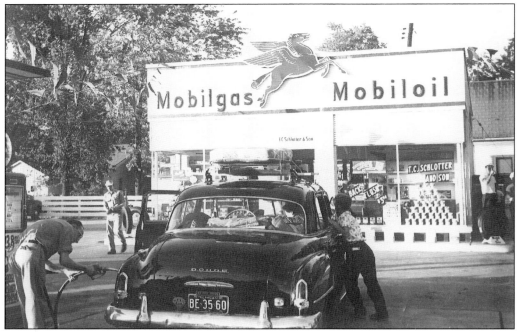

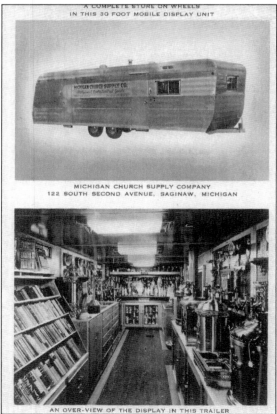

A COMPLETE STORE ON WHEELS
IN THIS 30 FOOT MOBILE DISPLAY UNIT

MICHIGAN CHURCH SUPPLY COMPANY
122 SOUTH SECOND AVENUE, SAGINAW, MICHIGAN

AN OVER-VIEW OF THE DISPLAY IN THIS TRAILER

Thomas C. Schlotter and his son James W. Schlotter operated a Mobil gas station at 300 South Warren Avenue in the early 1950s. This was a full-service station where an attendant pumped the gas, checked the car's oil, and washed the windshield. A dollar's worth of gas would get a driver three gallons. (Author's collection.)

Raymond Products Company, at 1200 Rust Street, was one of the nation's first manufacturers of mobile homes. The company started by making wood parts for truck bodies and cabs in the early 1920s. In 1931, it started making travel trailers. The Travelo was popular with sportsmen and military personnel. Saginaw Products Corporation bought the company in 1968. This Travelo carried and sold church supplies. (Courtesy of Robert Merritt.)

Saginaw's Modart Corset Company, founded in 1900, was a major manufacturer of women's corsets and other undergarments. Saginaw entrepreneur J. Bert Pitcher was the company's owner. Its 200 employees made four corsets per minute. A typical corset used eight yards of lace and 100 whalebone stays. Most corsets weighed nearly five pounds. The company closed in 1932, a victim of 1920s fashion and the Great Depression. (Author's collection.)

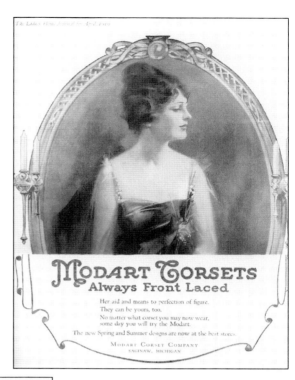

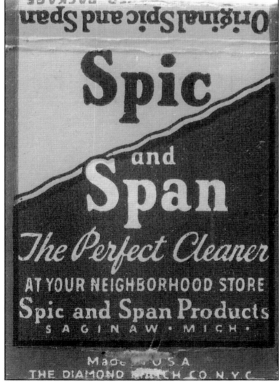

Spic and Span was developed and manufactured in Saginaw in the early 1930s by the partnership of Harold and Naomi Stenglein and Glen and Elizabeth MacDonald. In 1933, Saginaw homes were heated with coal-burning furnaces. When the heating season was over, walls needed to be washed to rid them of black streaks from the heat registers. Spic and Span, a glue-based cleaner, needed no rinsing or wiping. (Author's collection.)

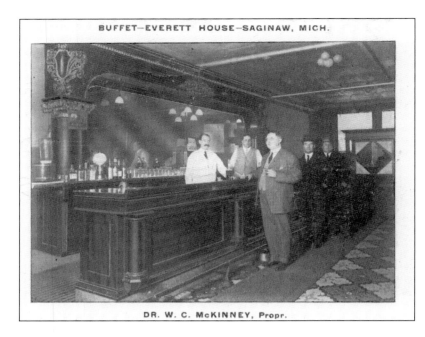

BUFFET—EVERETT HOUSE—SAGINAW, MICH.

DR. W. C. McKINNEY, Propr.

The Everett House opened in the 1860s at East Genesee and Franklin Streets. It was a favorite place of the shanty boys who came to the city after working in the northern woods all winter. In the early 1900s, it was a popular place after 15 bathrooms were installed. The hotel was razed in the 1920s. (Courtesy of Robert Merritt.)

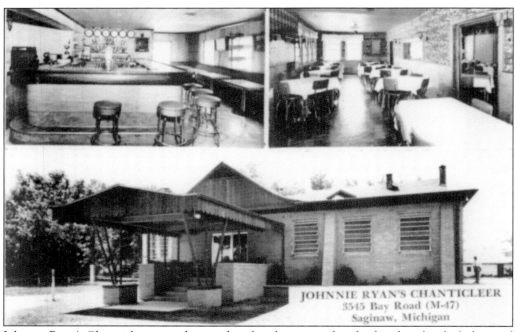

JOHNNIE RYAN'S CHANTICLEER
3545 Bay Road (M-47)
Saginaw, Michigan

Johnnie Ryan's Chanticleer was advertised as the ultimate in fine food and cocktails. It featured full-course dinners and a lobster display tank with live lobsters, which was a novelty of the establishment. There were two public dining rooms, three private banquet rooms, and a cocktail lounge. The owners were Johnnie and Margaret Ryan. Johnnie also sponsored a women's softball team that practiced on a diamond behind the restaurant. (Courtesy of Robert Merritt.)

Four

THE WAR YEARS

During the war years of the early 1940s, everyone in the country was gladly trying to do his or her part in the nation's war effort. There was a nationwide scrap drive, collections of old 78 records and nylon and silk stockings, and contributions to the Red Cross. War bonds and war-stamp booklets were sold. The Junior Red Cross filled Christmas boxes for the unfortunate children in Europe. (Author's collection.)

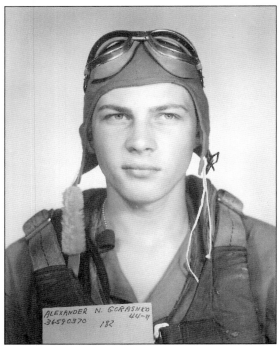

Saginaw aerial gunner Alex Gorashko was awarded silver wings, having graduated from the gunnery school at Harlingen, Texas. Flying as a tail-gunner in a B-24, his plane's mission was to destroy the oil refineries at Blechhammer, Germany. During the mission, his plane was attacked and shot down on August 22, 1944. Of the 10 crew members, only Gorashko and a waist-gunner survived to be taken prisoner by the Germans. (Courtesy of Alex Gorashko.)

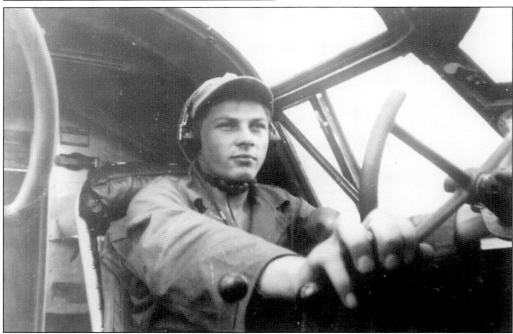

Aerial gunner Alex Gorashko was taken prisoner by the Germans when his bomber was shot down. His experiences included solitary confinement, life in the prison camp, continual hunger, and an 86-day march. Red Cross food packages were received, but the food needed to be shared four ways. May 2, 1945, was liberation day from the prison camp, Stalag Luft IV. "Freedom was like going to heaven," states Alex. (Courtesy of Alex Gorashko.)

Sgt. Victor Misekow enlisted in the Army in April 1941 and saw five years of service during World War II as a member of the 3rd Infantry Division's 10th Field Artillery Battalion. A career Army man, he reenlisted in 1946 and again in 1948. He was sent to Korea, where he was seriously wounded in action in January 1951. He died of his wounds. (Courtesy of Alex Gorashko.)

Pvt. Victor M. Marfuta, drafted into the Army in March 1941, arrived in Manila on November 24, two weeks before the Japanese attack. After the fall of Bataan and Corregidor, he was taken prisoner and forced to partake in the infamous Bataan death march. He worked at hard labor as a captive of the Japanese for three years. Initially at 140 pounds, he weighed 85 pounds when liberated. (Courtesy of Alex Gorashko.)

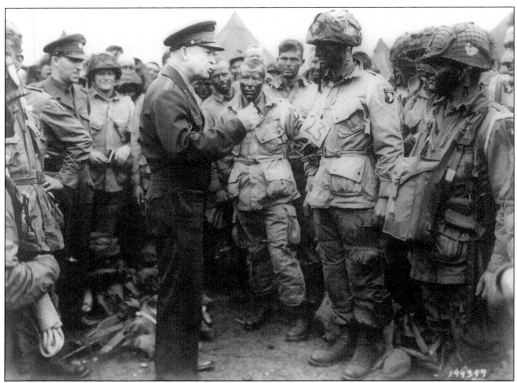

Wallace Strobel, born and raised in Saginaw, is the soldier pictured here with General Eisenhower before the D-day invasion. The image became so famous that it was on display for many years in the Pentagon and was also on a first-class postage stamp. Wally became good friends with John Eisenhower, Ike's son, and was invited to participate in the 40th and 50th anniversary celebrations of D-day in France. (Author's collection.)

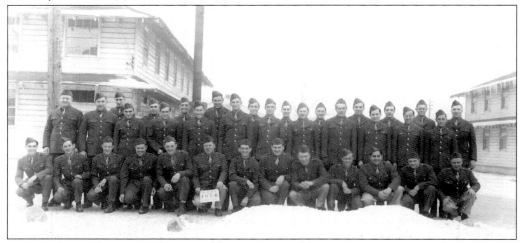

In 1940, Camp Custer was designated Fort Custer and became a permanent military training base. During World War II, more than 300,000 troops trained there. Here, a group of draftees, including men from Saginaw, have gathered for a picture in the winter of 1943. Fort Custer also served as a prisoner-of-war camp for 5,000 German soldiers until 1945. (Author's collection.)

Raymond Barry (1918–2005) was a survivor of the Bataan death march. Ray entered the Army in May 1941 and was sent with his unit to the Philippines in October. He was captured when Bataan surrendered to Japanese forces in April 1942. He spent three years as a prisoner of the Japanese. After his release, he was awarded the Silver Star, Bronze Star, and Prisoner of War Medal. (Courtesy of Mary Sue Barry.)

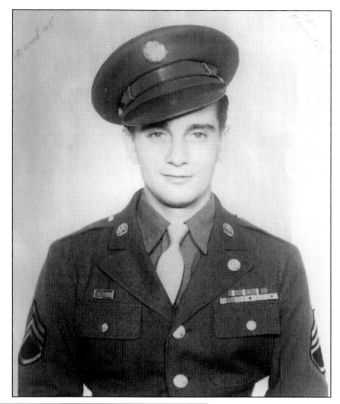

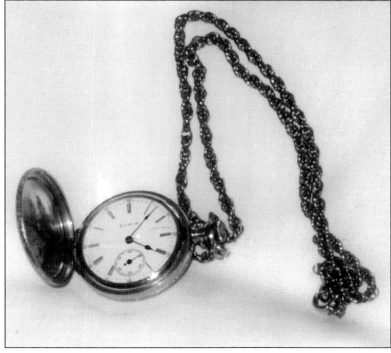

The watch that Sgt. Ray Barry kept hidden from his Japanese captors for three years was given to him by his mother. Mounted in a wristwatch case, he concealed the watch around his ankle during the Bataan death march. While in captivity, he continued to find ways to hide the watch. After his release, he had it restored with the original chain. (Courtesy of Mary Sue Barry.)

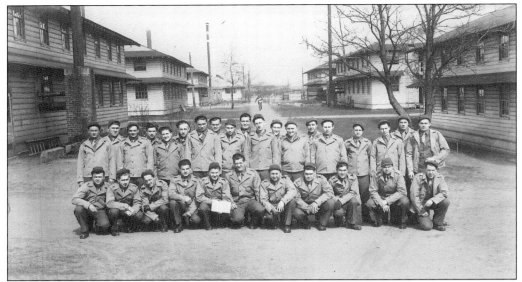

On April 3, 1943, a contingent of Saginaw boys left the Michigan Central Railroad station on West Genesee Street for Fort Custer. Arriving there, the draftees were issued bedding and had the choice of bunks in several empty barracks. Later, the men were issued uniforms and completed a battery of tests to determine in which branch of the service to place them. Next, they were called outside for a group photograph. (Courtesy of Alex Gorashko.)

"V For Victory" was the theme of the war years from 1941 to 1945. Saginaw mothers were recruited to take jobs in the war plants. Ration stamps and red and blue tokens were issued to families to purchase gas, sugar, and other rationed items. Victory gardens were planted to raise vegetables and fruits. There were long waiting lists for families to buy automobiles or appliances. (Author's collection.)

In 2005, the Saginaw County Veterans Organization entered into a lease with the City of Saginaw to create and maintain a memorial area at Hoyt Park. It was expanded to place memorial monuments from each of the wars in which Saginaw residents served. The brick walkway was financed by donors, who purchased bricks printed with the names of loved ones who served in various conflicts. (Author's collection.)

The World War II Memorial at Hoyt Park is one of four maintained by the Saginaw County Veterans Organization; the others are for World War I, Korea, and Vietnam. The Gulf War and Middle East conflict memorials may soon be added. The gardens and walkways are tended by volunteers. Memorial bricks continue to be added by families wishing to honor those who served their country. (Author's collection.)

The Blue Star Service Banner was patented in 1917 and quickly became the unofficial symbol for parents with a son or daughter in active military service. The blue star banners hung in windows, indicating the number of household members serving in the military. If a serviceman was killed, a gold star replaced the blue star. Churches also had banners in their sanctuaries, with stars representing members in the armed forces. (Author's collection.)

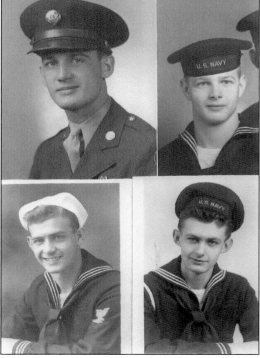

Many families during World War II had more than one son in the armed forces. The George Halm family of Saginaw had Robert in the Army and William, Donald, and John in the Navy. Another family with four sons serving was the Babechenko family. Their four boys—Paul, John, Walter, and Nick—were all in the Army. Both families had all four of their sons return home after the war. (Author's collection.)

"Vet's Park," or "River Road Park" is a 30-acre roadside park along the Saginaw River and a four-lane highway linking Saginaw and Bay City. It was named Veteran's Memorial Park by an act of the Michigan Legislature. The Civilian Conservation Corps was given the task of developing the park during the Great Depression. It was assigned the landscaping of the 1,100 acres along the river. (Author's collection.)

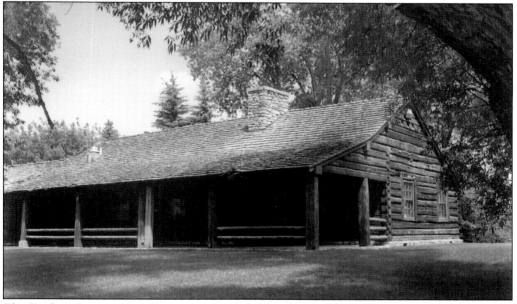

The Civilian Conservation Corps was assigned the task of building a large cabin from the sunken timber dredged from the Saginaw River. Work on the cabin started in 1935 and was constructed mostly by veterans who desired that it be a veterans museum. There were displays in the cabin, but it never turned into a memorial building. After sitting empty for some time, it was dismantled and sold in 2006. (Author's collection.)

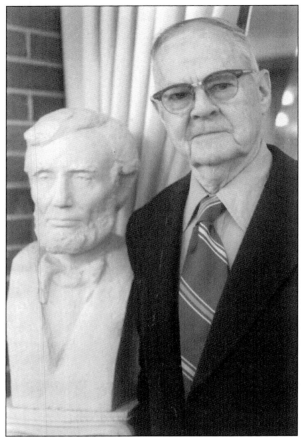

Dr. Richard D. Mudd (1901–2002) was an Air Force colonel during World War II who invented a battlefield blood-transfusion system that saved countless lives in combat. Most Saginawians, however, remember him as the Dr. Mudd who tried all of his life to exonerate his grandfather Samuel Mudd, who was accused in the Lincoln assassination. He was a Lincoln scholar who acquired a vast collection of Lincoln memorabilia. (Courtesy of Thomas Mudd.)

The Aleda E. Lutz VA Medical Center in Saginaw was designated on August 15, 1990. Aleda Lutz was a celebrated World War II flight nurse and the only female recipient of the Distinguished Flying Cross. Lutz, a 1st lieutenant, flew 196 missions and evacuated over 3,500 men. In November 1944, during an evacuation flight from the front lines near Lyons, Italy, her plane crashed, killing all aboard. (Author's collection.)

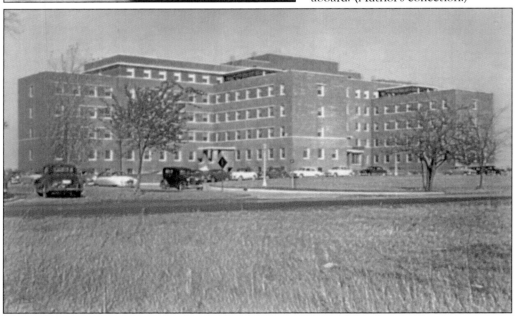

Five

SCHOOLS

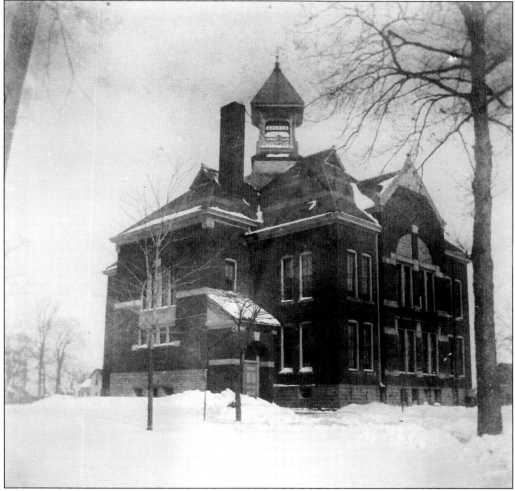

This school was named for David H. Jerome, Saginaw resident and former governor of Michigan. Jerome School was located at 1501 South Harrison Street. The brick building was two stories tall and had a bell tower. It contained eight classrooms in which seven grades were taught. The original school, built in the 1890s, was replaced in 1913; there were additions in 1920 and 1941. (Author's collection.)

In 1913, a new Jerome School was built on the site of the original. Pictured here during a recess period in 1946 are, from left to right, Arvilla Moss, fifth-grade teacher; Berneeta Pedlow, fourth-grade teacher; and Margaret Pieritz, sixth-grade teacher. (Author's collection.)

During the 1946–1947 school year, the PTA officers of Jerome School were, from left to right, Irma Eurich, Ella Kabobel, Mildred Canter, Leona Russell (president), and Margaret Krenz (secretary). Meetings were held at the school on the second Thursday of the month. (Author's collection.)

Pictured on June 4, 1947, are the fifth-grade girls in Margaret Pieritz's class. From left to right they are (first row) Sue Johnson, Gail McCallum, Sheila Wright, and Sue Cushway; (second row) Dolores Duranso, Shirley Bell, Sally Brassem, Pearline Callas, Pieritz, Mildred Dean, Mary Stricker, Joyce Siems, and Nancy O'Conner. The photograph was taken by firth-grade class member Roberta Krenz. (Author's collection.)

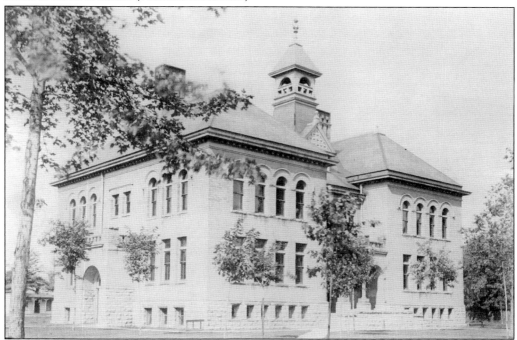

Stone Elementary School on State Street near Stone Street is named for Farnum Chickering Stone, an area grocery and hardware merchant who was also treasurer of the Saginaw City Board of Education for many years. The first Stone School, built in 1889, was torn down and replaced with a new building in 1970. (Author's collection.)

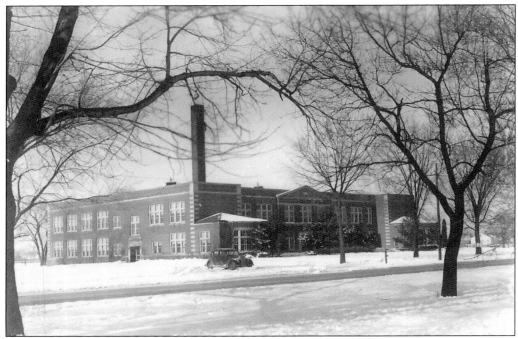

The original Handley School at 3021 Court Street was named for Cassius Handley, the principal of Emerson School from 1896 to 1928. It was a neighborhood school, with one wing for special education classes. Later, it became the school for the gifted and talented. In 2007, it was demolished, and the Willie Thompson Middle School was built on the site. (Courtesy of Saginaw Public Schools.)

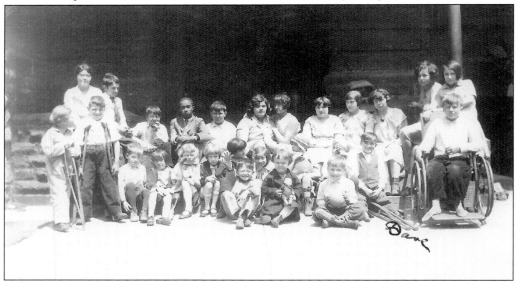

In 1929, this group of handicapped youngsters attended Handley School. Handley housed classes for the deaf, blind, and children with special needs. There were also rooms for occupational and physical therapy. Later, a school for children with special needs was built in Bridgeport, Michigan, and named for Melvin Millet, the longtime principal of the special education section of Handley School. (Author's collection.)

Hoyt School was built to replace the old "Academy," which burned in 1871. The old school was always known as the Academy because of its stately appearance. Hoyt School opened in November 1872 with room for 325 students. It was replaced and enlarged again in 1892 with room for 400 students. (Author's collection.)

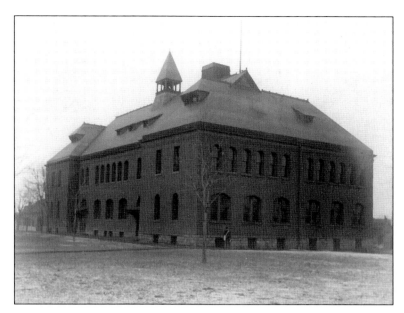

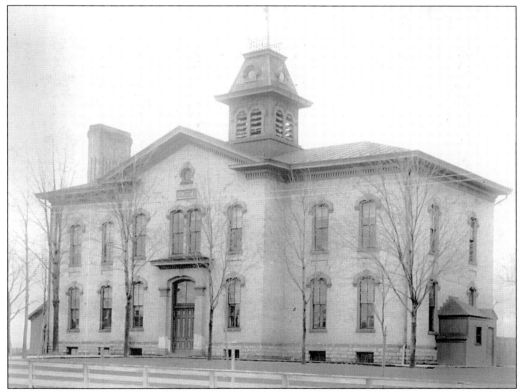

In 1874 the Sweet School was built in the Seventh Ward of East Saginaw. It was a two-story brick building with a large bell tower. The new school replaced a smaller wooden building located on the same site. Between 1870 and 1875, the demands for more classrooms to accommodate the growing number of pupils who desired to enter school were at a peak. (Author's collection.)

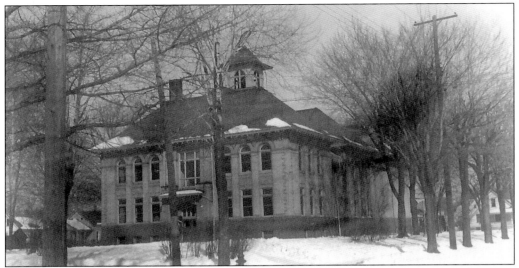

Durand School, situated at the corner of Grout and Joslyn Streets, is named after a longtime president of the board Lorenzo T. Durand. The school was erected in 1904 and enlarged in 1915. It had 13 rooms, and German was included in the curriculum. Durand was a lawyer who prosecuted many notable cases, including that of Silver Jack Driscoll, a rowdy lumberjack who frequently ran afoul of the law. (Author's collection.)

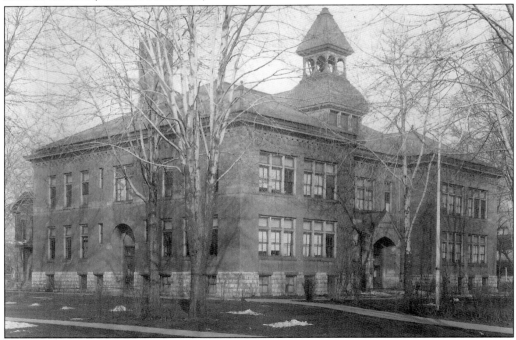

Emerson School's address is 1124 Findlay Street. Although some would like to think that this school was named for the New England poet, the school was actually named for Saginaw's own colorful, brawling, generous Curtis Emerson. Emerson, also a New Englander, made his fortune in lumber and shipbuilding. His home, known as the Halls of Montezuma, was the scene of many memorable parties, which schoolteachers did not attend. (Author's collection.)

Named for its benefactor, who willed the school district $200,000 to establish and maintain a trade school, Arthur Hill Trade School was a career center built on the west side in 1913 and located on the corner of Michigan Avenue and Mackinaw Street. When enrollment dropped in the 1960s, the building was closed and vocational courses were offered at the Career Opportunities Center on Weiss Street. (Courtesy of Saginaw Public Schools.)

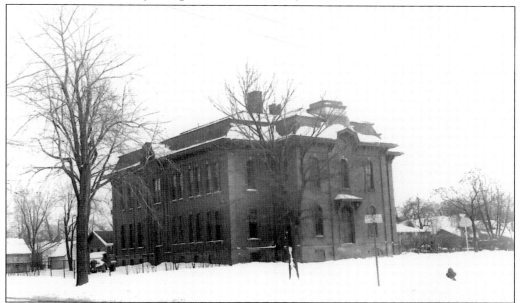

Crary School, which replaced the First Ward School, was built on Carroll Street between North Warren Avenue and Weadock Street and opened in 1868. Originally containing four rooms, it was later enlarged by the addition of four classrooms to accommodate the growing number of students in this section of the city. As early as 1900, the school had a classroom for hearing-impaired children. (Courtesy of Saginaw Public Schools.)

Fuerbringer Elementary School, built in 1931 at 2138 North Madison Street, was named for Dr. Gustavus H. Fuerbringer, a Saginaw physician. In 1933 and 1934, it had the only PTA glee club in the nation. The vocalists were all men, and they performed throughout the area as well as at the school. Declining enrollment caused the school to be closed in 2008. (Author's collection.)

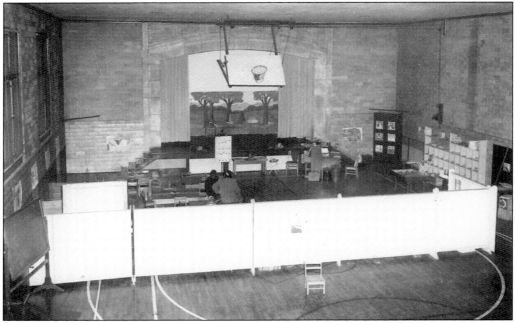

During the 1960s, the student enrollment was such that gymnasiums were divided to make room for two additional classrooms. This meant that the gym could not be used for indoor activities. The portable dividers separated each temporary classroom. Often, the temporary rooms were used by traveling art or music instructors. (Author's collection.)

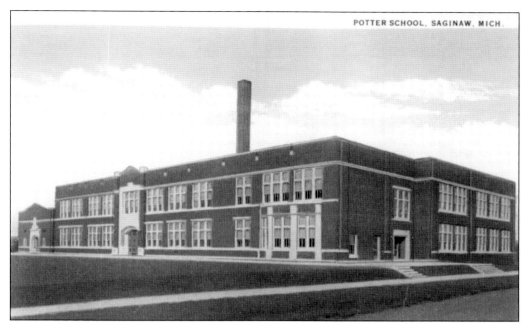

Potter School was built in 1870 on Sixth and Norman Streets and was named for Henry C. Potter, a pioneer businessman. The four-room wooden structure stood for 20 years until a brick building replaced it in 1890. Fire destroyed it in 1928, and the new school pictured here was completed in 1929. The Saginaw School District closed the building in 1981; it was demolished several years later. (Author's collection.)

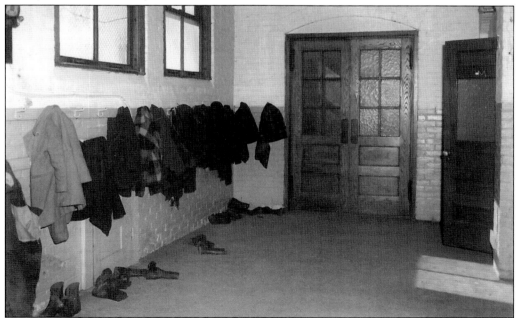

During the 1930s and 1940s, most elementary schools did not have lockers. The students hung their coats and took off their boots in the cloakroom. Hats and coats were hung on hooks in a closet-type room off the main classroom or, as pictured, in a basement room. (Author's collection.)

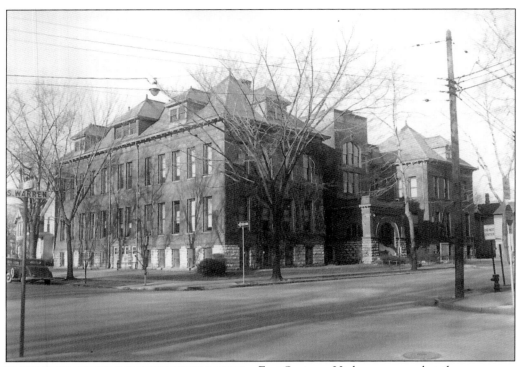

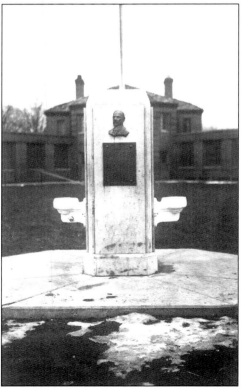

East Saginaw High was opened at the corner of Warren Avenue and Millard Street in 1880. It was a two-story brick building, and it was one of the first Saginaw schools to have the luxury of central heating. In 1893, Saginaw High was extensively remodeled and enlarged. In 1905, the school day there lasted only from 8:30 a.m. to 1:30 p.m. (Author's collection.)

In 1910, Alumni Field was bought for outdoor sports events and developed by alumni on both sides of the river. The stadium was shared until Arthur Hill High built its own stadium. A monument to Franz Drierer, Saginaw High's legendary first director of physical education, was dedicated at Alumni Field. Drierer was hired in 1906 and was remembered as an excellent coach who ran his classes with the iron discipline of the Prussian army. (Author's collection.)

The Germania School at Lapeer and Johnson Streets was a three-story structure built in 1868 and was the first area school to offer kindergarten. In 1870, the school joined East Saginaw Public Schools. During World War I, when anti-German sentiment was at an all-time high, the school's name changed to Lincoln School. In 1911, teacher Emily Bruske arranged her first-grade class on the lawn for this photograph. (Author's collection.)

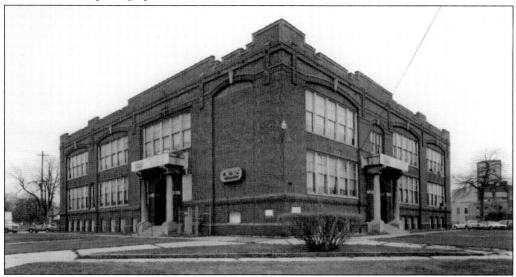

The new Germania School was designed by noted Saginaw architect Fred Beckbissinger. The school was completed in 1914 at 1000 Tuscola Street at the corner of Fourth Street. Because of the anti-German sentiment during World War I, the name of the school was changed to Lincoln School. The building was later used as the Opportunities Industrialization Center of Metropolitan Saginaw. (Author's collection.)

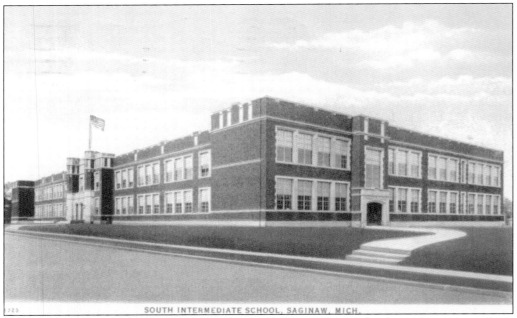

SOUTH INTERMEDIATE SCHOOL, SAGINAW, MICH.

South Intermediate School, along with three other junior high schools in the city, was built in 1922. The junior highs were more than just schools; some served as social centers for their neighborhoods. The buildings were open day and night for activities. On weekends, the auditoriums featured movies, vaudeville, theatricals, and musicals. Once a year, each school developed a special fundraising event to help support events there. (Author's collection.)

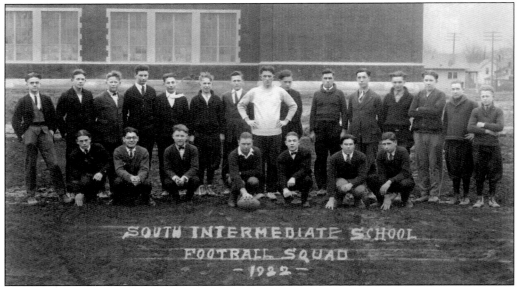

SOUTH INTERMEDIATE SCHOOL
FOOTBALL SQUAD
- 1922 -

Even though this postcard features the 1922 South football squad, the sport did not last long at the junior high level. Football was considered too rough for junior high students, so soccer was substituted until 1959. Boys' teams played basketball, baseball, and track. Girls were also involved in sports; their teams included volleyball, track, basketball, and baseball. The junior high schools competed against each other. (Author's collection.)

Chester Miller Elementary, located at 2010 Brockway Street, was built in 1963 to accommodate students when South Elementary closed. Pictured here is the 1967 faculty of Miller. Posing for the photograph are, from left to right, (first row) Ingrid Van Auken, Eunice Russell, Nellie Dvorsek (secretary), Jane Brenner (principal), Mary Toole, Marjorie Chapin, and Geraldine Green; (second row) Vivian Walch, Phyllis Christensen, Donna Wurtz, Philip Bechtol, Zetta Bedore, Catherine Medler, and Dorothy Lingenfelter. (Author's collection.)

For 50 years, Virgil and Marjorie Nobel guided a group of junior high youngsters to Washington, DC, during Easter break. Beginning in 1935, the trip was a popular vacation for students who were mainly from South Intermediate School, where Virgil was a teacher and coach. Touring buildings and meeting congressmen were highlights of the trip. The Nobels are fourth and fifth from the left in the fifth row. (Author's collection.)

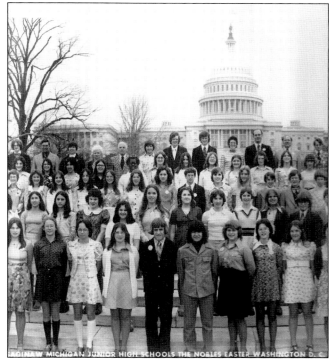

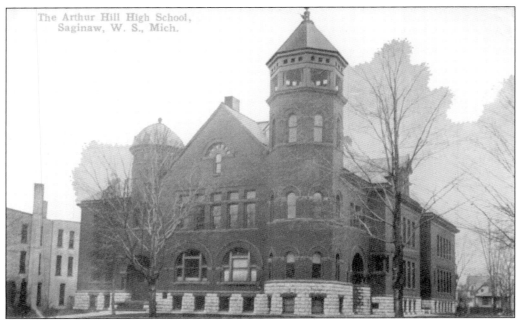

The Arthur Hill High School, Saginaw, W. S., Mich.

The original Arthur Hill High School opened in 1888 at the corner of Court and Harrison Streets. Originally named West Saginaw High School, it was renamed in 1893 for lumber baron Arthur Hill, who established four scholarships. A $1,000 award was given each year to the top graduate with the provision that he or she attend the University of Michigan. (Author's collection.)

Arthur Hill was born on March 15, 1846. He attended public schools in Saginaw before earning a civil engineering degree from the University of Michigan. After working with his father and brother in the lumber business, he formed his own lumber company and a steel steamship company. In spite of business demands, he was highly involved in public service and civic activities in Saginaw and Ann Arbor, Michigan. (Author's collection.)

This is Arthur Hill's 1909 football team in the uniforms of the era. Included in the photograph are, from left to right, (first row) Daniel Butterfield, Ralph Khuen, Harry C. Buell, and coach ? Brook; (second row) Harold E. Zuber, Edward D. Schoerner, Jackson W. VanBrunt, Chester F. Gregory, Joseph J. Fordney, and Harold C. Roeser; (third row) Leo Vondette, Clement P. Quinn, captain Thaddeus Elliot, and Emil A. Tessin. (Author's collection.)

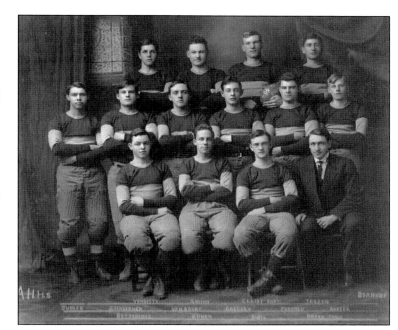

The Arthur Hill homecoming parade began in 1931. There were cars and trucks decorated in the school colors of blue and gold. The homecoming queen and her attendants rode on the all-school float. The parade started at Thistle Field, the football practice field, which is the site of today's Andersen Enrichment Center. The procession continued through downtown, ending at Alumni Field. (Author's collection.)

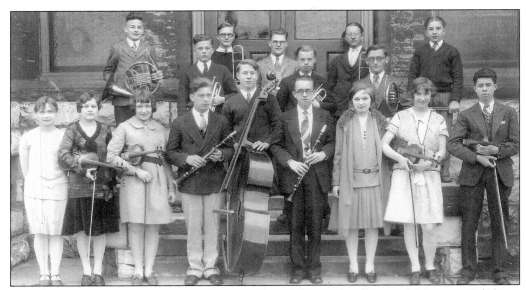

The 1929 Arthur Hill orchestra members are, from left to right, (first row) Margaret Salisbury, Naomi Paquette, Irene Salisbury, Carl Glave, John Spenner, Lyman Miessner, Florence Schendel, Elizabeth Teck, and Lyle Schumate; (second row) Jack Spatz, Robert Miles, and David Block; (third row) Roy Paquette, Earl Smith, Mr. Nelson (director), William Nagel, and Richard Grams. (Author's collection.)

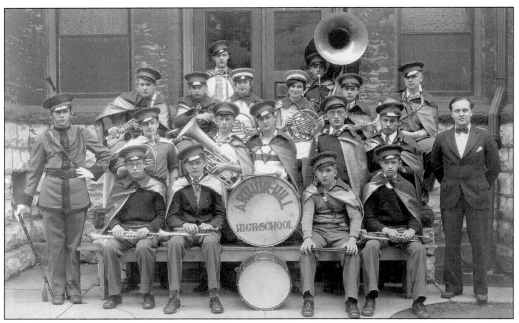

The 1929 Arthur Hill band was 17 members strong. Ivan R. McCormack, the director, added a drum major for performances. In 1930, the band added new members, which increased their numbers to 30. The initial appearance of the band was at the Arthur Hill–Cass City football game. To purchase additional uniforms, the group sponsored an all-school party in the fall and a tea dance in the spring. (Author's collection.)

Alumni of the old Arthur Hill "castle" watched with sadness as the building on Court and Harrison Streets was razed. It was referred to as the castle by students because of the tower on the right front of the building. For 50 years, the school was a part of the busy west side section of Saginaw. Students were apprehensive about moving to a new school "out in the country." (Author's collection.)

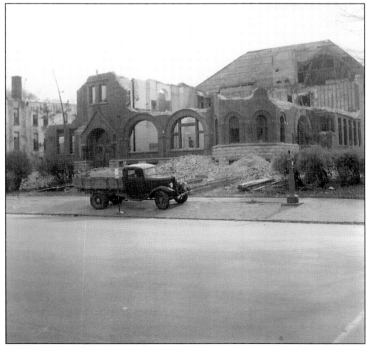

The 1939 yearbook featured photographs of the old Arthur Hill High School and an architect's sketch of the new building. The dedication page read, "To those thousands of students who have enjoyed the halls and classrooms of this building, which has housed west side high school students for fifty years, we dedicate this fortieth yearbook." The board of education received $22,500 for the site at Court and Harrison Streets. (Author's collection.)

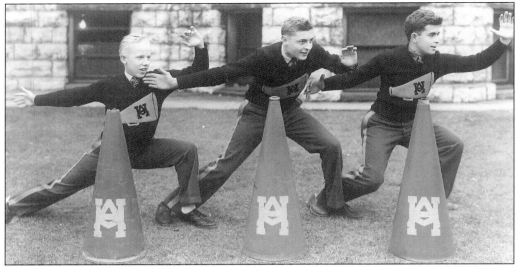

In 1937, cheerleaders were young men wearing sweaters indicating their positions. Girls during these years were known as song leaders. Pictured here are, from left to right, Jack Eberlein, Jerry Brenner, and Bob Leckie Jr. They led the crowds to cheer heartily for their team. (Author's collection.)

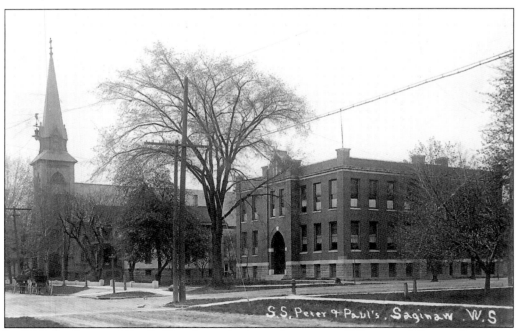

In 1888, St. Peter and Paul's Church was built on the corner of Wayne and Fayette Streets on Saginaw's west side. Continued growth of the congregation and need for a school resulted in a new church and 21-room school in 1909. In 1915, the school had 13 teachers and 400 pupils. (Courtesy of Robert Merritt.)

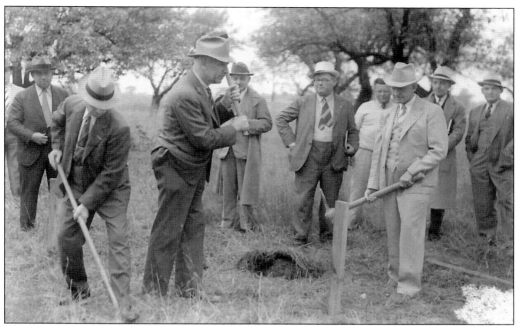

At Malzahn and Mackinaw Streets, the 72 acres known as the Schemm farm were purchased from the estate, as it proved to be the most convenient center for the new Arthur Hill High School. The workmen broke ground on September 7, 1938, with a contract to have the building completed in a year. The government appropriated 45 percent of the total $1.25 million cost. Franz & Spence were the chosen as the architects. (Author's collection.)

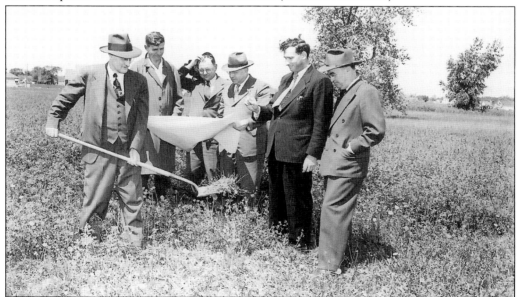

The ground-breaking for Arthur Hill's Memorial Stadium took place in the fall of 1949. Julius A. Ippel, a Saginaw merchant, turned the first shovelful of earth. At the ceremony are, from left to right, Julius Ippel, two unidentified men, Chester F. Miller (superintendant of schools), an unidentified man, and I.M. Brock (principal of the school). (Author's collection.)

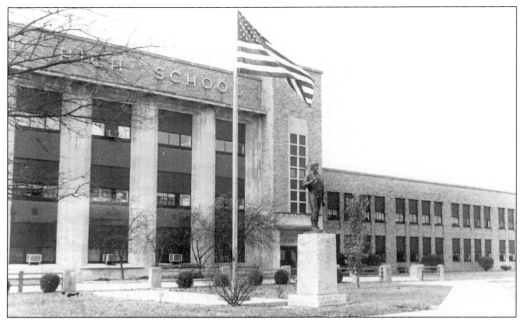

The nickname "Lumberjacks" has remained since 1930, when students chose the name in a student election. It debuted at the annual Thanksgiving Day football clash with the Trojans of Saginaw High School. In 1990, a Lumberjack statue was dedicated as part of the "new" school's 50th anniversary. The bigger-than-life statue on the front lawn shoulders an axe that is lit up at night. (Author's collection.)

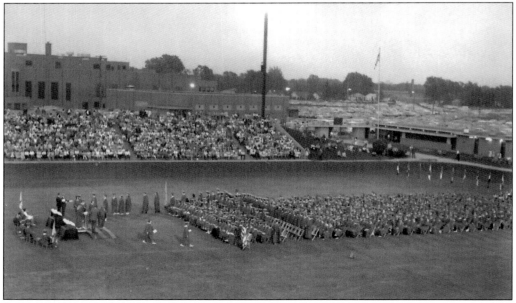

Senior week marked the end of three years as Hillites. In February, seniors were measured for caps and gowns, which were distributed on the last day of classes. Included in the final activities were the senior dinner and prom. When the June weather cooperated, graduation at Arthur Hill High School was held in the memorial stadium. (Author's collection.)

In 1957, Charles C. Coulter, pictured on the left, became superintendent of schools when Chester F. Miller retired. During Coulter's 10-year tenure as the school's chief, many new school programs were initiated. When he retired in 1967, civic leaders lauded his steady leadership and good deeds. Coulter died on August 23, 1994. Board of education president Harold Karls is shown here with Coulter. (Author's collection.)

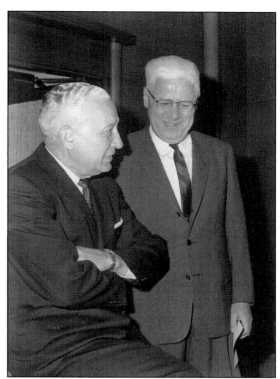

Irl M. Brock had a long and distinguished career in school circles. He came to Saginaw in 1925 from Illinois, taking the job of principal at South Intermediate School. In 1929, he became principal of Arthur Hill High School, a position he maintained until his retirement in 1962. During his tenure at the high school, the new school at 3115 Mackinaw Street replaced the outdated building on Court Street. (Author's collection.)

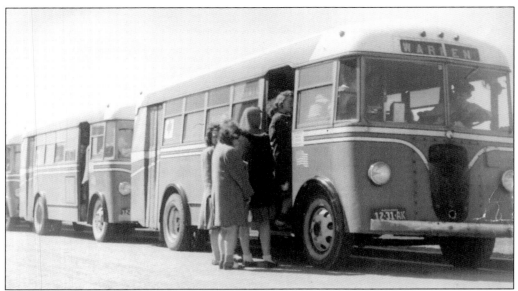

With the move to the school on Mackinaw Street, not many Arthur Hill students were within walking distance, nor did many drive a car to school. Students were either driven to school or rode one of the city buses. At the end of classes, buses were lined up with a street sign indicating their route. (Author's collection.)

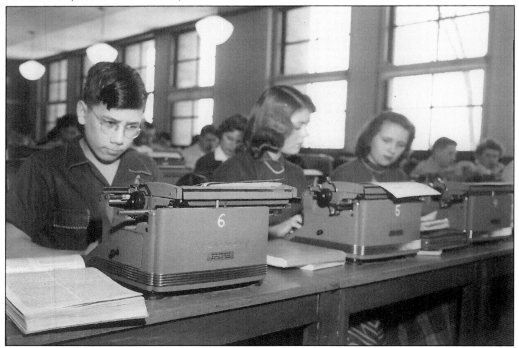

In typing class in the 1950s, Underwood typewriters were the norm. Typing the most words per minute was the goal. If a mistake was made, there was no backspacing to correct it. Erasers were handy; if a carbon was inserted to make an additional copy, both pages needed an eraser. At the end of a line, the carriage was moved when the machine's bell signaled the end. (Author's collection.)

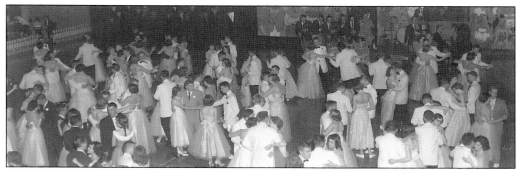

The senior prom was a formal affair held in the school gymnasium. Girls in ankle-length formals and boys in white dinner jackets were the popular attire. The Arthur Hill dance band furnished the music. The band also played for all Club Hillite dances, the Band Bounce show, and school assemblies. (Author's collection.)

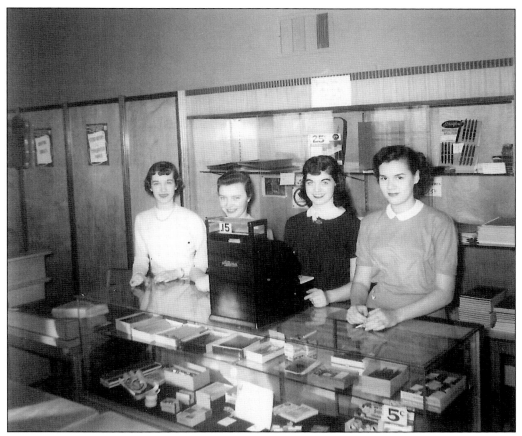

The commercial department at the high school offered varied subjects to students in preparation for the business world. In 1956, the student store was open each morning from 8:00 a.m. to 8:45 a.m. and during the lunch period. The clerks are, from left to right, manager Donna Wruck, Janice Reeves, Beverly Fahndrick, and Judy Felder. For their work, they received a paid-up student organization ticket that allowed them into any school activity, such as sports events and dramatic and musical productions. (Author's collection.)

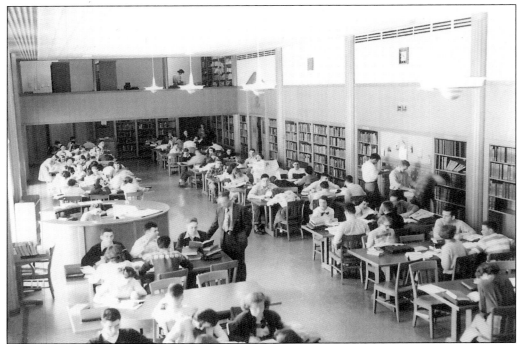

Study Hall was held in one of two well-lighted 30-by-120-foot libraries. When the school on Mackinaw Street opened in 1940, the libraries were said to accommodate 440 students six hours a day. There was a librarian and reference material on hand to help students with homework or projects. Usually, a classroom teacher was in charge during study times. (Author's collection.)

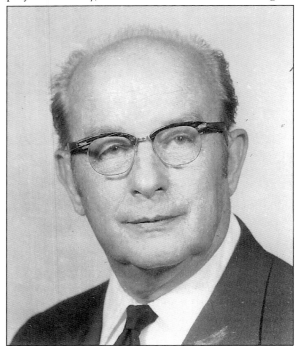

Stanley Schubert, a institution at Arthur Hill High School, retired in 1959 after 36 years as an English and dramatics teacher. After retirement, he volunteered at the Saginaw County Juvenile Home, the Saginaw Historical Society, the YMCA, and his church. He sent CARE (Cooperative for American Remittances to Europe) packages to Finland. He said he chose Finland because that was the only country that paid its debts to America. (Author's collection.)

Six

ARTISTS, WRITERS, AND MUSICIANS

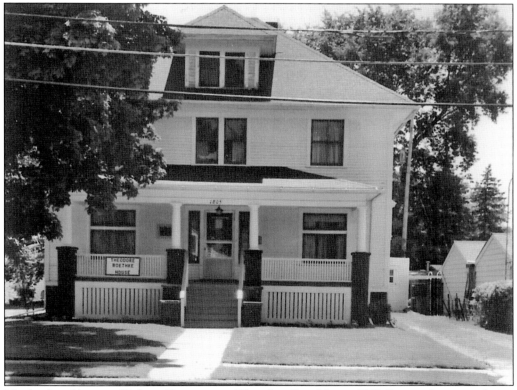

The boyhood home of Pulitzer Prize winner Theodore Roethke, at 1805 Gratiot Avenue, is being restored and is included in the National Register of Historic Sites. The renovation is under the care of the group Friends of Theodore Roethke. Next door is the home of Roethke's Uncle Carl Roethke, which will become a center with classrooms and rooms for visiting artists. A Michigan Historic Marker stands at both homes. (Author's collection.)

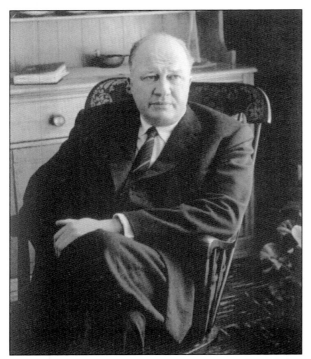

Theodore Roethke (1908–1963) was born in Saginaw on May 25, and that location, its people, and its environment were central in his works throughout his life. After Arthur Hill High School, he attended and earned a degree in English from the University of Michigan. He taught at the University of Washington, where he helped to create the writing program. In 1954, his collection, *The Waking*, was awarded the Pulitzer Prize. (Author's collection.)

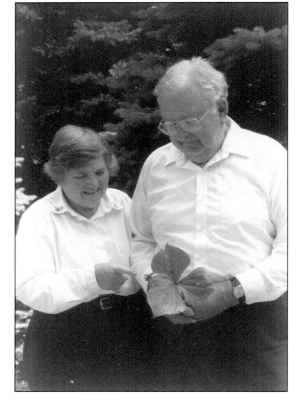

Frederick Case and his wife, Roberta, were partners in plant studies for some 40 years. Hardy explorers, they trekked through swamps and woodlands to see and photograph each of the North American trillium species in the wild. They also grew all the American trillium species in their experimental gardens at their home. Their book, *Trilliums*, is part field guide and part gardener's handbook. (Courtesy of David Case.)

Jack Jonker (1948–2010) received his BA and MA degrees from the University of Michigan. Music was Jack's passion. He moved to Saginaw in 1970 and took a job teaching music at Delta College. In 1977, he was named music director and conductor of the Saginaw Choral Society, a position he held for 25 years. He won an All Area Arts Award and a Teaching Excellence Award. (Author's collection.)

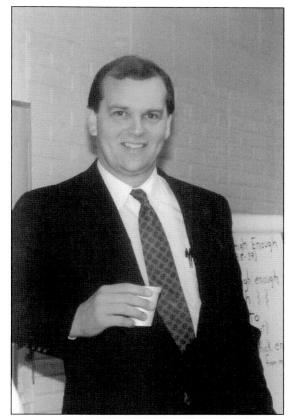

Stewart Franke's music often reflects his upbringing in Saginaw. In 1995, his first album, *Where The River Meets The Bay*, was a look back at his youth. Although the recipient of many music awards, he has also received awards for his work with leukemia, bone marrow, and cancer foundations. Stu, a bone marrow transplant survivor, is working on a new album while continuing with his foundation work. (Courtesy of Stewart Franke.)

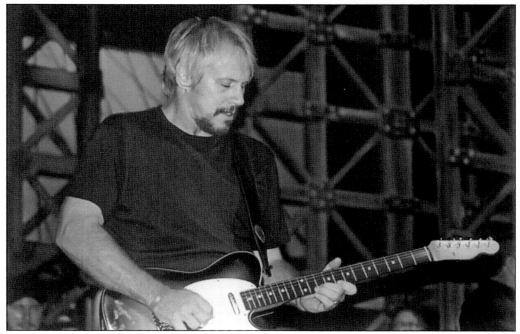

Eanger Irving Couse (1866–1936) was born in Saginaw, where as a child he became familiar with the large Indian population that lived nearby. As a youth, he regularly visited the local settlements of the Chippewa and Ojibwa tribes to sketch the natives. His formal artistic training began at the Art Institute of Chicago. From there, he studied in New York and later in Paris. (Courtesy of Hoyt Library.)

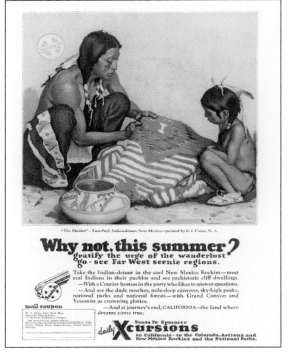

Eanger Irving Couse was married in Paris. After moving with his wife to the Northwest, he completed his first Indian paintings of the local tribes. Hearing of the beauty of New Mexico, he took to Taos, which was everything he had dreamed of. His artistic desires were satisfied as he studied and painted the Pueblo Indians. Much of his work was displayed on calendars and in advertisements for the Santa Fe Railroad. (Author's collection.)

Bill Galarno, a Saginaw native, has traveled extensively as a theater professional. He resides in New York and is a produced playwright, with awards from the American Society of Composers, Authors and Publishers (ASCAP) and the New York State Council on the Arts. During the 1966 transit strike in New York City, he borrowed a bike and cycled to auditions, classes, and appointments without missing one. In 2010, he appeared in *Two Gentlemen of Verona* at the New York Theater. (Courtesy of Bill Galarno.)

Tony Award winner Jack O'Brien returned to Saginaw in 2006 for the 50th reunion of his 1956 graduation from Arthur Hill High School. Pictured with other classmates, the well-known director, producer, writer, and lyricist has won three Tony Awards and been nominated for several more. He has directed and produced musicals, contemporary dramas, opera, and Shakespeare and has won five Drama Desk Awards. (Courtesy of Patricia Stoppleworth.)

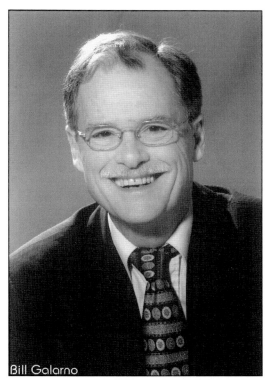
Bill Galarno

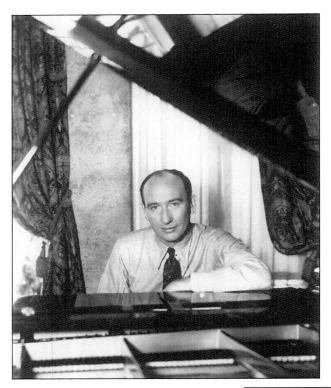

Isham Jones (1894–1956) was born in Ohio to a musical family but grew up in Saginaw, where he started his first band. The band made a series of gramophone records throughout the 1920s. His popular dance bands during the 1920s and 1930s played at many Saginaw locations. Among Jones's music compositions were "I'll See You in My Dreams" and "Swingin' Down the Lane." (Author's collection.)

Charles K. Harris was born in New York in 1867. His father was a fur trader who moved his family to Saginaw, where Charles grew up. In 1891, he wrote "After the Ball," which caught the attention of John Philip Sousa, who played it, helping sales soar to five million copies. His next hit, "Break the News to Mother," earned him the name "king of the tear jerkers." (Author's collection.)

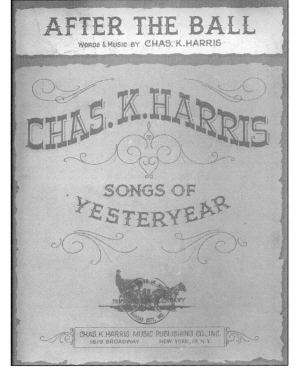

AFTER THE BALL
WORDS & MUSIC BY CHAS. K. HARRIS

CHAS. K. HARRIS

SONGS OF YESTERYEAR

CHAS. K. HARRIS MUSIC PUBLISHING CO., INC.
1619 BROADWAY NEW YORK, 19, N. Y.

Jean Beach is a freelance artist and writer who has maintained an interest in Saginaw history and has written many articles and books on the area. She has written a history of First Congregational Church and a book on the work of artists Julia and Henry Roecker. Jean carries her sketch pad with her to the many meetings that she attends. (Courtesy of Jean Beach.)

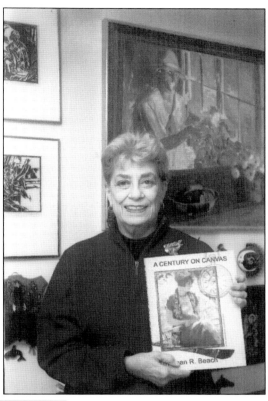

Mattie Gay Crump taught English and journalism at Arthur Hill High School from 1926 to 1967, helping her students earn multiple press awards. She advocated freedom of expression and emphasized it with her students. In her own right, she received many accolades during her career. Posthumously, she was inducted into the Michigan Journalism Hall of Fame. (Author's collection.)

Brian d'Arcy James is a Saginaw-born American actor and musician. A graduate of Northwestern University, he received a Tony Award nomination for his portrayal in *Sweet Smell of Success*. He received an Obie Award for his performance in *The Good Thief*. Other Broadway credits include his roles in *Titanic* and *Dirty Rotten Scoundrels*. Recently, he had the lead role in *Shrek, the Musical*. (Courtesy of Brian d'Arcy James.)

Aside from being a very successful businessman, Howard C. Heath was an avid barbershop quartet singer. He was a member of the Barons of Harmony, the 1947 State of Michigan Barbershop Quartet champions and a member of the Preservation and Encouragement of Barbershop Quartet Singing in America. He founded Heath Meat Company, a pioneer in the service of meats to hotels and restaurants. (Courtesy of Marilyn Dust.)

Seven

FAIRS, PARKS, AND FESTIVALS

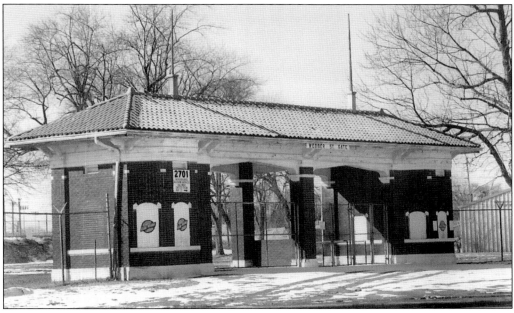

The original gate to the Saginaw Fair was this Webber Street gate, constructed around 1928 in a Chinese pagoda architectural style. The Saginaw County Fair was once the largest fair east of the Rocky Mountains and drew hundreds of visitors. The fair faced decline during the 1960s and was moved in 2002 from the city's downtown to fields in Chesaning, Michigan. (Author's collection.)

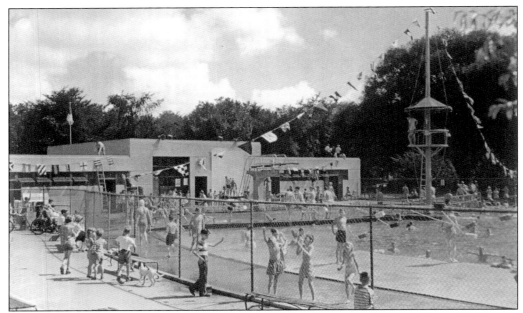

Andersen Pool, opened in 1937, was Saginaw's largest swimming pool and made possible by civic leader Frank N. Andersen. During the 1940s and 1950s, it was the place to be on a hot summer day. In 1952, for the year, more than 90,000 swimmers spent a day at the pool. (Author's collection.)

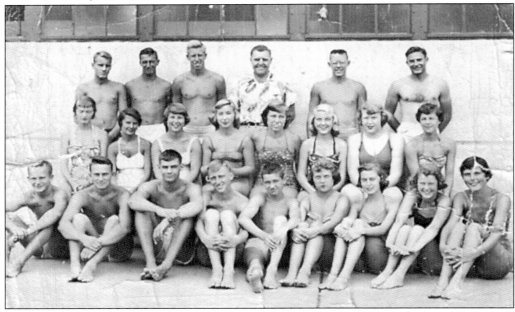

The Andersen Pool staff members in 1952 are, from left to right, (first row) James Elliott, Jack Anderson, Herbert Heitkamp, Donald Carroll, Joseph Cawley, Gloria Duwe, Mary Holmes, Carolyn Gilbert, and Mary Young; (second row) Mary Ellen Cox, Sally Brown, Joan Vondette, Sally Jungerheld, Bessie Means, Gloria McFarland, Donna Mae Kyes, and Julie Holmes; (third row) Donald Morey, Duane Maas, Richard Goodrow, Floyd Byron, Robert Bossman, and James MacMillan. (Author's collection.)

Bliss Park was originally part of fur trader Louis Campau's holdings along Michigan Avenue. Formerly known as Butcher's Woods, the property was purchased from the Campau family in 1905 by former governor Aaron T. Bliss for use as a park. The site was also where the 29th Regiment Michigan Volunteer Infantry organized for the Civil War in 1864. (Author's collection.)

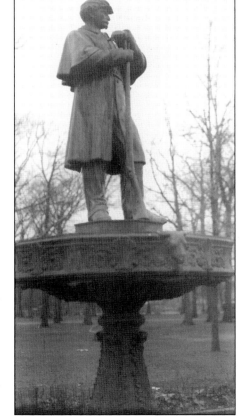

Originally located in Federal Park was the Soldier's Fountain monument and fountain, donated by Aaron T. Bliss as a memorial to his comrades who fell in battles of the Civil War. In 1938, prior to the construction of an addition to the post office, the fountain was moved to Bliss Park. The fountain was toppled over by an intense windstorm in 1940, severely damaging the figure. Today, only the base and plaque remain. (Author's collection.)

In 1939, Frank N. Andersen, who founded Andersen's Sand and Gravel Company, donated all the concrete to build the pool on Rust Street. He also gave an additional $12,000 to build additional seating capacity for spectators. The Andersen Pool building usually had a lineup of boys and girls on a summer afternoon waiting to enter the locker room and pool area. (Author's collection.)

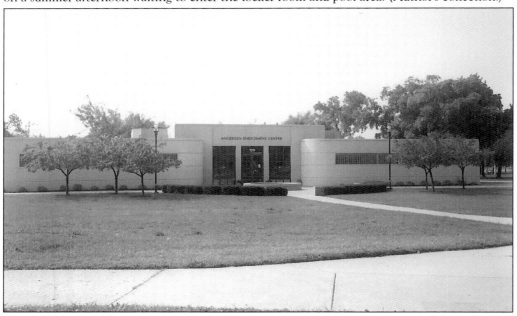

The Andersen Pool building was remodeled to become the Andersen Enrichment Center. Located in the middle of the city's central parks system, the center and the adjoining Lucille E. Andersen Memorial Garden offer a unique atmosphere for weddings and receptions. Within the building are the Garden Room, overlooking the rose garden, and the Hall of Fame Room. A Marshall Fredricks sculpture adorns the center of the fountain in the garden. (Author's collection.)

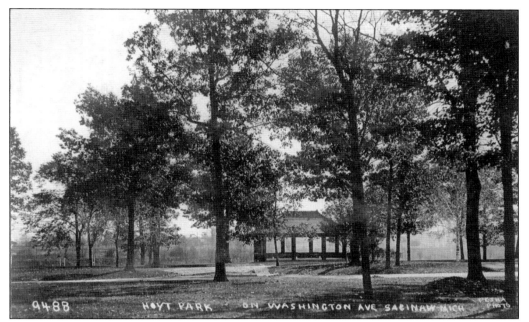

Hoyt Park was originally the James Riley reserve before Jesse Hoyt gave a part of it to the city. The land was a low-lying swamp full of water critters and was not drained until the 1890s. By 1904, the weeds and brush were cut, roadways laid out, and the park began to host summer baseball and winter skating. The popular park's use by the public was year round. (Author's collection.)

Always a popular feature at Hoyt Park was George's Popcorn Wagon. With the slogan "Here is George" written on the front of his truck, George Coenis was the refreshment-stand man for many years. The city allowed George concession-stand rights every year. Along with popcorn and candy corn, youngsters could buy delicious caramel or red candy apples. (Author's collection.)

Pictured is a parade on North Washington Avenue with decorated wagons rolling past 200–206 North Washington Avenue, which was the Saginaw Valley Drug Company. The business included the wholesaling of a full line of drugs, soda fountains, and heavy chemicals, also sporting goods and fancy articles. The four-story building employed 42 people. (Author's collection.)

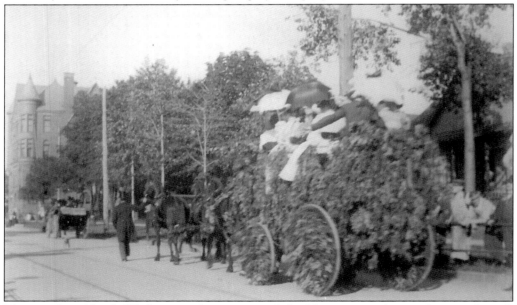

Moving along North Washington Avenue toward the Masonic temple was this parade with floral-decorated buggies. The parade was part of the semi-centennial celebration in August 1907. Many businesses participated in the parade with floats to advertise their establishments. (Author's collection.)

Principal Maurice Guy places the crown on the queen of the South School Spendless and Seemore Circus. In 1951, the school celebrated its 20th circus. Principal Guy attempted to locate all 19 of the former circus queens. Pictured with Principal Guy are queen Roberta Krenz and attendants Pearline Callas and Marcia Fluke. (Author's collection.)

Each March, the students at South Intermediate School presented a circus. It consisted of student talent acts. Here, Judy Dingman does a toe dance. Some acts were repeated each year with different participants, such as the girls' tap-dance routine and the swinging ladder act. During the 1930s, professional acts were added, including animal acts, aerial acts, balancing acts, and professional clowns. (Author's collection.)

Pictured in 1952, these two tap dancers at the South School Circus are Carmen Brown (center) and Ann Gomon (right). Most costumes were designed and made by pupils and teachers, though at times a few special costumes were rented. Admission to the show was 50¢ for adults and 25¢ for children. Proceeds went into the school's general fund to purchase such things as award letters, pins, athletic uniforms, and audiovisual equipment. (Author's collection.)

Boys on the swinging ladders were coached by professionals in the circus business. Vernon Howay of the Flying Vernons, a big-time circus act, offered to train students. Others who stepped forward to help were Happy Holmes, the famous clown, and Tierra Koski, America's foremost ladder artist. During March 1947, the circus was almost postponed because of a severe snowstorm, but with the determination of students the show went on. (Author's collection.)

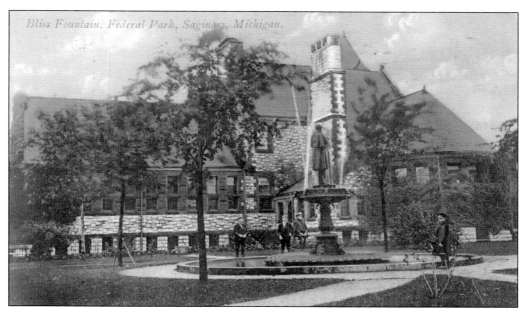

Bliss Fountain, Federal Park, Saginaw, Michigan.

Federal Park was a small park between the post office and Hoyt Library about one acre in area, with plantings of trees and shrubs. In the center of the park is the soldiers monument and fountain, which was erected by Aaron T. Bliss as a memorial to his comrades who fell in battles of the Civil War. (Author's collection.)

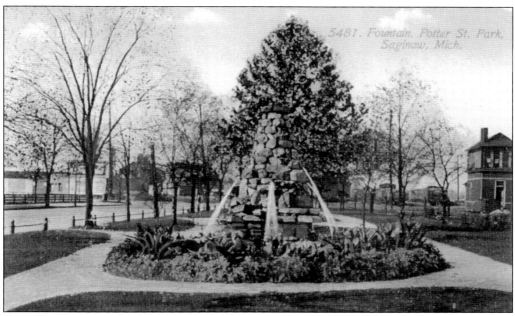

5481. Fountain, Potter St. Park, Saginaw, Mich.

Potter Park was a small strip of land bordering on Potter Street and the railroad named for Dr. Henry C. Potter. The Flint & Pere Marquette Railroad donated part of its property for the park. The fountain had a column of cobblestone and a basin also constructed of cobblestone. Several jets of water streamed from the top; other streams shot out a few feet lower and fell upon stone slabs. (Author's collection.)

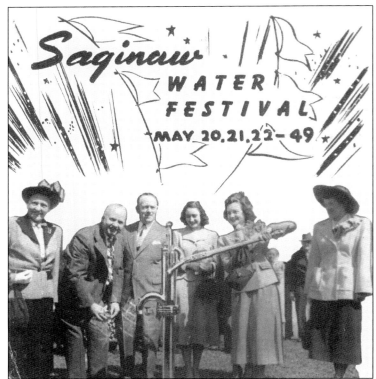

In 1949, the Saginaw community celebrated the bringing of pure water to the area. Sponsored by the Saginaw Board of Commerce, the festival created community-wide cooperation. A Water Festival Queen was chosen from representatives of four sections of the city. Twenty-one-year-old Joyce Hayes, the east-side representative, was elected queen. The old corner water pumps were no longer needed when the "World's best water" was drawn from Lake Huron. (Author's collection.)

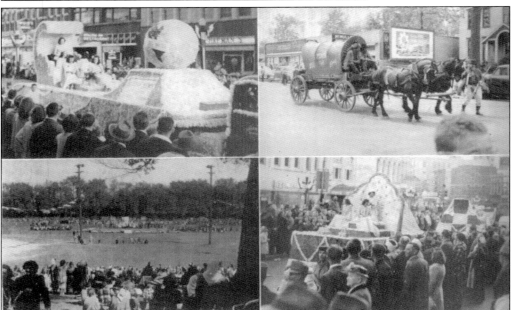

The Water Festival in 1949 included parades, queens, speeches, and even the burial of an old corner pump. From New York, Saginaw's songsmith Gerald Marks sent the official song, titled "There Never Was a Place Like Saginaw," to be sung by Marion Newberry. A corner pump was buried on the Water Works property with city councilmen serving as pallbearers. (Author's collection.)

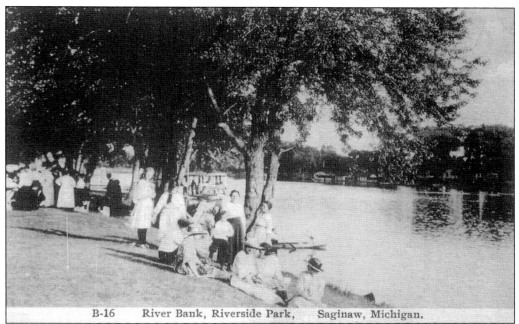

B-16 River Bank, Riverside Park, Saginaw, Michigan.

The Union Street Railway built Riverside Park in 1894 at the foot of Michigan Avenue on the banks of the Tittabawassee River. The park was built to supply evening- and weekend-paying trolley riders. Often free or discounted passes were available for riders who could enjoy the amusement park or picnic on the riverbank. The fare kept the railway company profitable during the post-lumber years. (Author's collection.)

In 1905, W.B. Mershon announced plans to put gray squirrels in Saginaw's parks and neighborhoods. Firefighters built squirrel houses in the yards of prominent citizens. The management at Riverside Park arranged to import several dozen fox squirrels. In 1906, William S. Linton announced 100 pairs of squirrels would arrive in town on May 25. It was believed that the squirrels would become a charming feature in the city. (Author's collection.)

At the dance pavilion at Riverside Park, people danced to the music of the bands of Jules Pockrandt, Maurice Rushlow, and Danny Russo. In the summer of 1925, promoter Ernest Mesle ran into the blue law that prohibited dancing on Sundays. So that there could be dancing on that day, he placed the orchestra behind a screen. He was fined $10 for defying the law. (Author's collection.)

Marathon dancers at Riverside Park danced and danced and danced except for a few minutes at given intervals to freshen up. For the contestants, it was a grind. They danced for days and days, and the promoter gave prizes to the winners—those on the floor when everyone else had quit. Admission was charged for spectators, who came to watch and tried to guess who would drop out first. (Author's collection.)

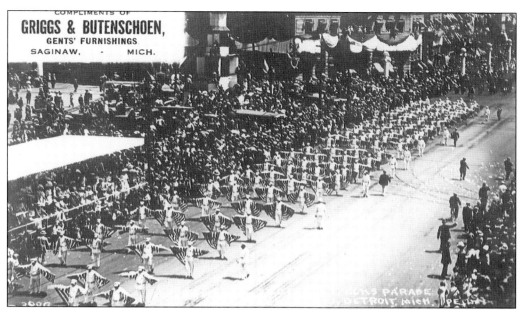

The Saginaw Lodge, No. 47 of the BPO Elks, was instituted June 23, 1886. The purpose of the club was to aid and protect its members. Beginning with 14 members, the club grew to 300 when they participated in the parade in Detroit in 1910. The Elk's Temple on Germania and Warren Avenues was built to accommodate 400 members; it was enlarged to provide for 1,100 members in 1916. (Author's collection.)

The Merlin Grotto had for its purpose the bringing together of all Masons into one common body and promoting the spirit of good fellowship. In 1920, Lodge 77 bought the 1855 Youmans farm in Bridgeport and transformed it into a golf course. The group built the Merlin Grotto Country Club at a cost of $35,000 on the 60-acre site. The Bugle Corps performed at festivals and parades. (Author's collection.)

The Mershon-Whittier Natatorium kept Saginawians cool during the heat of summer. The city's first public swimming pool opened in 1910. During the pool's early years, the Saginaw River was the water source, and women swam only on Tuesdays and Thursdays. The natatorium closed in 1962. The following year, a new Mershon Pool opened at South Ninth and Tuscola Streets. It closed in 1992. (Author's collection.)

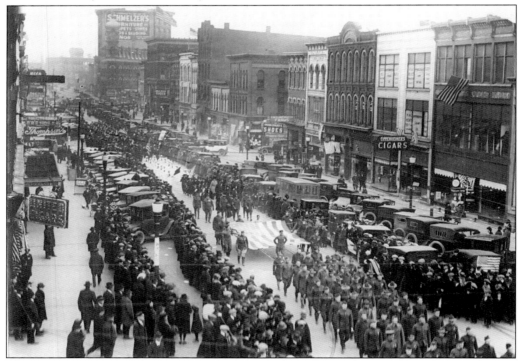

The Armistice Day Parade on East Genesee Street brought out the crowds. Each year after the end of World War I, Saginaw remembered the armistice with a parade. In 1919, Pres. Woodrow Wilson proclaimed November 11 as Armistice Day (also known as Remembrance Day) to remind Americans of the tragedies of war. Thousands turned out to pay homage to the war dead in this 1921 photograph. (Author's collection.)

Eight

DISASTERS

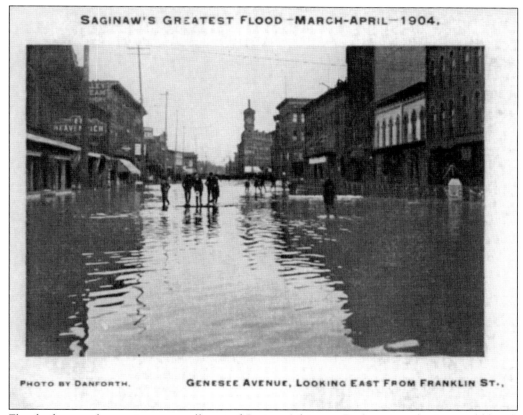

Floods, fires, and snowstorms are all part of Saginaw's history. Each spring, the ice would break up on the river, and with the thaw East Saginaw streets would flood. Any late snowstorms would add water to the river already swollen by the thaw. Another disaster was the great fire of 1893, which destroyed 257 buildings in East Saginaw. (Author's collection.)

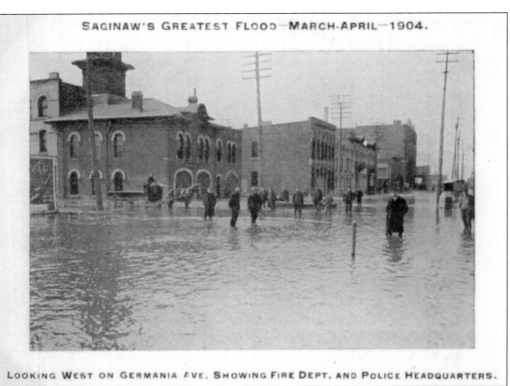

SAGINAW'S GREATEST FLOOD—MARCH-APRIL—1904.

LOOKING WEST ON GERMANIA AVE. SHOWING FIRE DEPT. AND POLICE HEADQUARTERS.

The fire department and police headquarters along flooded Germania Avenue were at a standstill during the flood of 1904. The high water nearly separated the two Saginaws. The only means of communication was the Bristol Street Bridge. In East Saginaw, millions of dollars worth of property was destroyed. Factories shut down, and railway and streetcar services were suspended. (Author's collection.)

Werner and Pfleiderer, a German company that made mixing and kneading machines for the baking, chemical, pharmaceutical, and rubber industries, came to Saginaw in 1897. The company was sold in 1920, and its name changed to Baker Perkins Manufacturing Corporation. Britain's APV Chemical Machinery, Inc., bought the company in 1987, and B&P Process Equipment and Systems bought APV in 1995. This scene was shot of the company during the 1912 flood. (Author's collection.)

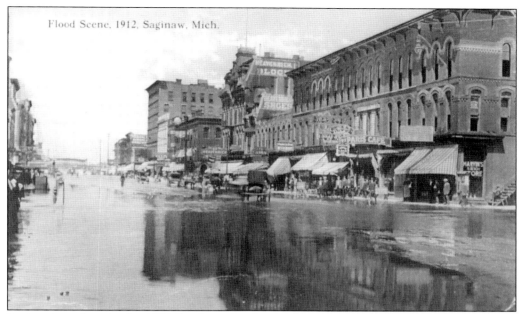

Saginawians thought the 1904 flood was the flood to reminisce about, but along came another in 1912 and then another in 1916. For years, there were no floods, but in 24 hours in 1986, a staggering 8.54 inches of rain fell. City residents and business owners were caught sleeping when the torrential rain filled Saginaw streets and basements. (Author's collection.)

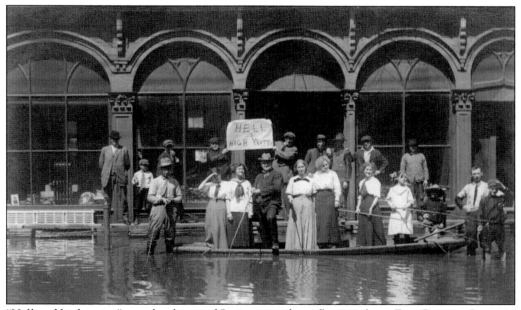

"Hell and high water" was the slogan of Saginaw residents floating down East Genesee Street in duck boats. When not in a boat, shoppers could get around downtown on elevated plank walkways. From 13 to 16 inches of water were in the stores along Genesee. The streets were not only full of water, but also with chunks of ice. (Courtesy of Douglas Aikenhead.)

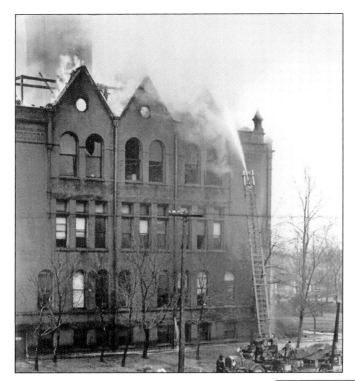

The city hall on South Washington Avenue, built in 1891, became a blazing inferno on April 9, 1935. The fire began in an unused elevator shaft and quickly spread throughout the entire facility. The city attorney and his secretary escaped down a ladder from a second-story window. The city treasurer saved $10,000 in currency by stuffing it in his pockets before escaping down a ladder. (Author's collection.)

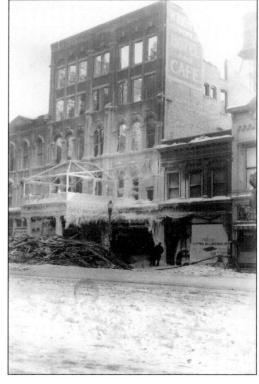

The Wright Hotel fire occurred on January 12, 1918, at 3:30 a.m., when the winds were blowing and the temperature was minus eight degrees Fahrenheit in the middle of a blizzard. The hotel, located at 114–116 South Washington Avenue, was one of 10 of East Saginaw's hotels. Some 40 guests were routed, and six people lost their lives. The fire was discovered by a bellboy. (Author's collection.)

Dawson's Emporium, on the corner of Hamilton and Ames Streets, was a well-known landmark in Saginaw until a devastating fire raged through the Hamilton Block on March 9 and 10, 1929. Water from the fire hoses froze into icicles, giving an eerie look to the building's charred shell. (Author's collection.)

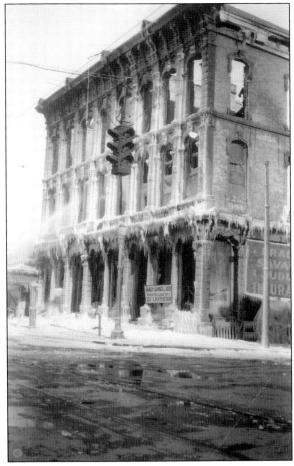

A full 13 businesses, 35 apartments, a three-story building, and most of a city block on North Hamilton Street in old Saginaw City were destroyed by a fire in March 1929. The blaze, known as the Hamilton Square fire, was one of the city's worst. The firefighters were hampered by the extremely cold temperatures. (Author's collection.)

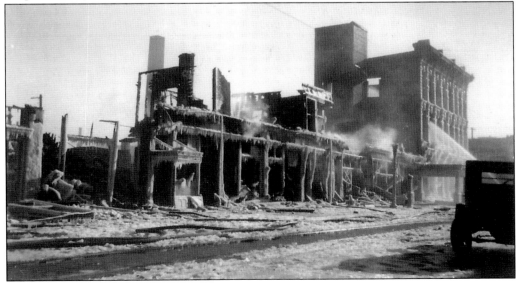

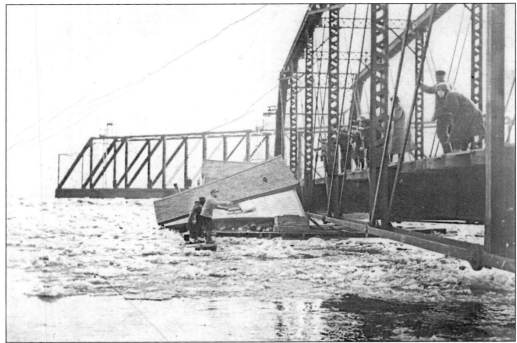

When snowstorms blew in and then melted quickly, Saginaw residents knew that floods were not far behind. If the Saginaw River had thick ice and lots of snow, a quick thaw meant the water had no place to go. The river became congested with ice floes that could take out bridges, and houseboats were doomed to destruction. Here, helpers on the bridge try to assist a houseboat owner. (Author's collection.)

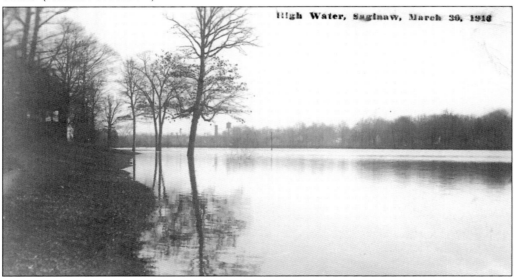

No one is playing on the Hoyt Park Playgrounds in March 1916. The low area, which once was a bayou, looked like a lake again. This was the area that featured activities during the semi-centennial celebration in 1907. During the summer, baseball was played on the diamonds, and in the winter skaters enjoyed the ice. (Courtesy of Robert Merritt.)

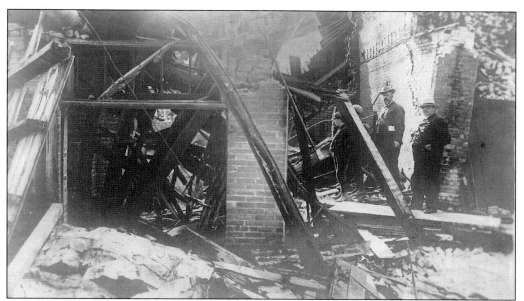

The Cosendai Cleaning & Dye Works, at 133 North Jefferson Avenue, was the site of an explosion and fire on July 6, 1906. Surrounding businesses were also damaged. Carl and Louis Cosendai and two workers were killed in the blast. John Cosendai, owner of the business, and another worker died later from injuries received when gasoline exploded at the business. City officials discussed possible regulations for gasoline storage in the city. (Author's collection.)

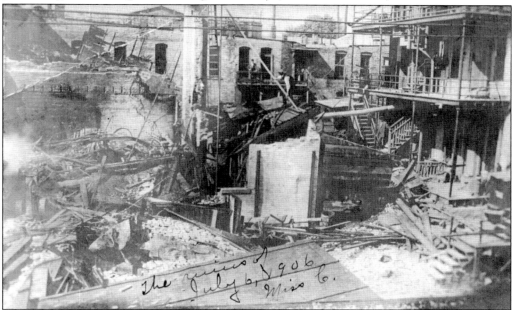

The message on this card reads, "The ruins of July 6, 1906." It was early on a Friday morning in July when an undertaker from Freeland brought funeral-wagon curtains to Cosendai Cleaning & Dye Works to be dyed. Within seconds, the man was sitting in the middle of the street covered with shattered glass. The explosion killed four; seven were taken to the hospital, where two more died. (Courtesy of Robert Merritt.)

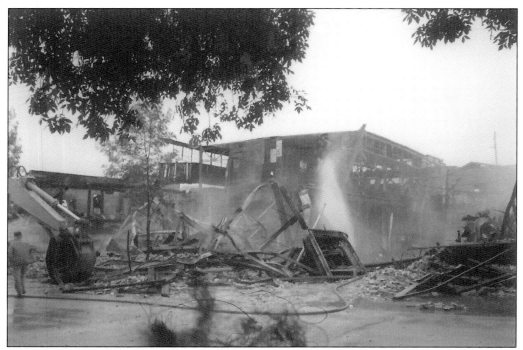

Jackson-Church-Wilcox Company, located on Hamilton Street, made essential parts for automobiles. The company developed a steering gear that was patented with the trade name Jacox. The largest customer for the gears was Buick Motor Company, which subsequently bought the entire property of Jackson-Church-Wilcox, along with the patent. The building on Hamilton Street is seen being razed in September 1992. (Author's collection.)

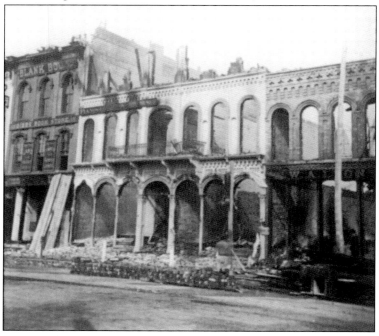

Jackson Hall was located on the east side of Washington Avenue across from the Bancroft House. Manager Samuel G. Clay attempted to bring "legitimate theater" performances to the city, but the local lumberjacks did not appreciate the performances. The hall was the scene of three suspected arson fires from 1870 to 1873. The Goodridge Brothers studio photographed the ruin. (Courtesy of the Castle Museum.)

Although not one of the largest storms, this one on April 28, 1909, was pictured on postcards because of the late date. One message read, "How's this for May Day? This is where the Parson lives." Two big storms occurred in 1908 and 1918, ten years apart on the same date of January 12. (Courtesy of Robert Merritt.)

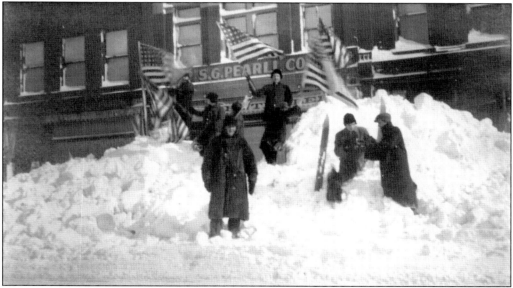

The great snowstorm on Washington's Birthday in 1912 caused Saginaw's population to be snowbound and looking for snow shovelers. This storm did not, however, compare with the record 30-inch snowstorm of January 1871. In 1912, because Washington's Birthday was not a school holiday, schoolchildren had the day off due to the snowstorm, and to remember the president's birthday they placed flags in the high snowbanks. (Author's collection.)

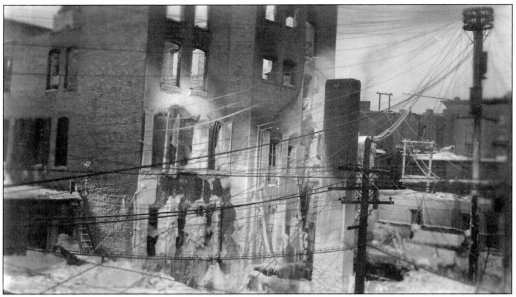

The Wright Hotel fire during the middle of the night in January 1918 caused the patrons to escape in their nightclothes. The Mueller brothers opened their store in the Bancroft Hotel across the street from the tragedy to supply clothing to guests of the Wright. The Bancroft Coffee Shop opened to provide hot coffee and shelter to the routed guests and firemen. (Author's collection.)

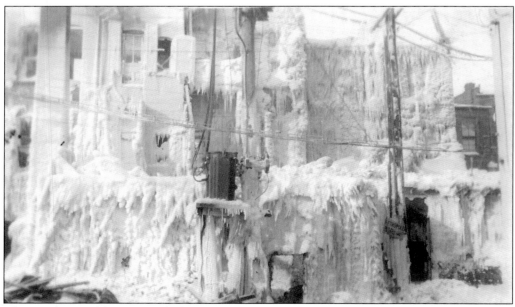

The Wright Hotel fire occurred when the temperature was so cold that firemen's clothing became frozen stiff and many suffered frostbite. Frank and Bill Mueller, whose store was in the Bancroft Hotel, provided firemen with heavy gloves, replacing those frozen into uselessness. Directly behind the Wright was the Franklin Hotel, whose guests were routed from their beds as a precaution. (Author's collection.)

Nine

NOTABLE ALUMNI

Emergency surgery performed by former Saginawian Dr. David Silver occurred in Cheyenne, Wyoming, in 2009, on a woman whose aorta wall split, leaking blood inside her vessel wall. Having been flown from Nebraska to the Heart and Vascular Institute, a 6 1/2-hour surgery saved her life. Dr. Silver had been notified of her condition and was ready to perform surgery when she arrived. She credits Dr. Silver and this procedure for saving her life. (Courtesy of Dr. David Silver.)

Rhythm ♥ of Life

Volume 2 • Issue 2 A publication brought to you by the Wyoming Heart & Vascular Institute Fall 2010

A Day of Miracles

Emergency surgery saves Nebraska woman's life —— page 6

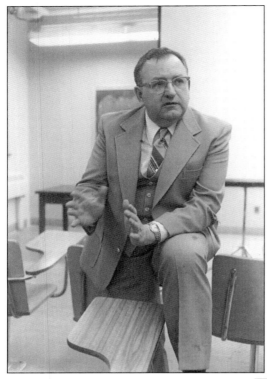

Frederick W. Case Jr. (1927–2011) was once asked why he chose to be a high school teacher instead of a college professor. His answer was that it afforded him more time to be out in the field studying plants. He was named Outstanding Biology Teacher in 1971, Outstanding Science Teacher in 1987, and Arthur Hill Honor Alumnus in 1978. Fred had a passion for plants and nature. He was an internationally acclaimed expert on North American native orchids, trillium, and insectivorous plants. With his wife, he authored three books and many articles for magazines and scientific publications. He lectured extensively, being associated with the University of Michigan Botanical Gardens, the Nature Conservancy, the Michigan Botanical Club, and the Saginaw Valley Orchid Society, among others. In short, he was an icon in the field of biology. (Both courtesy of David Case.)

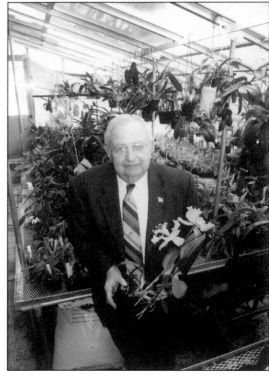

George Humphrey (1890–1970) graduated from Saginaw High School in 1908 and went on to become one of the nation's mightiest industrialists. In 1950, he was chairman of the board of the M.A. Hanna Company of Cleveland. From 1953 to 1957, he was secretary of the US Treasury during the Eisenhower administration. He was recognized as one of the most imposing personalities in Washington. "When George talks, we all listen," said Eisenhower. (Courtesy of Hoyt Library.)

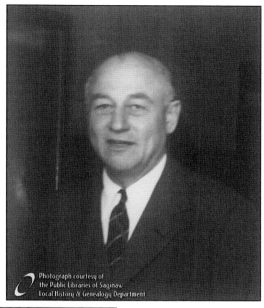

Photograph courtesy of the Public Libraries of Saginaw Local History & Genealogy Department

Robert W. Taylor, a Saginaw native and Michigan State University graduate, is CEO of a veteran-owned business. A major in the Air Force, Bob was a navigator on a B-52 bomber during the Persian Gulf War. His Alliant Healthcare Products develops, manufactures, markets, and distributes medical and surgical products. One division of the business focuses on research, while the other manufactures products, including cardiovascular devices, used in heart and lung bypass procedures. (Courtesy of Robert Taylor.)

Dr. David G. Silver graduated from Saginaw schools before attending Harvard University and Wayne State Medical School. He then trained at the University of Alabama and the University of Rochester in heart and lung surgery. David practiced medicine in Mobile, Alabama, before being recruited to Cheyenne, Wyoming, to start the heart surgery program there. *Money* magazine recognized his program for having one of the top heart-valve replacement centers in the country. (Courtesy of Dr. David Silver.)

Dr. Norma Powers Anderson is another Saginaw schools graduate who chose the medical field as her career. Norma has degrees from Capital University in Ohio, the University of North Carolina, and a PhD from Saint Louis University. Norma found her niche in nursing education. She retired after 35 years of teaching public health nursing at Saint Louis University, although she continues to teach an online course two semesters per year. (Courtesy of Dr. Norma Powers Anderson.)

Archibald H. (Archie) Stevens attended Saginaw schools and Michigan State University, majoring in business administration. He joined his father's company, Stevens Van Lines, in 1938, working his way up to the presidency of the organization. During his tenure, he built the company into a multi-location agency, serving customers on a national as well as international scope. During his business career, he served on the boards of many associations and community organizations. (Courtesy of Stevens Van Lines.)

The Honorable Terry L. Clark was born into a large family consisting of 10 brothers and sisters. He graduated from Buena Vista High School in 1973. From there, he attended and received degrees from the University of Michigan, Texas Southern University, and the Thurgood Marshall School of Law. On August 10, 1990, he was elected a judge of the 70th District Court in Saginaw County. He is on the boards of many community organizations. (Courtesy of Judge Terry L. Clark.)

Ted Kennedy Jr. (1920–2002) graduated from Arthur Hill High School in 1938. He went on to attend and play football at the University of Michigan, where he received honorable mention all–Big Ten. After serving as a Navy lieutenant in World War II, he earned an MBA at the Harvard Business School. He partnered with his father to start the Trenton Corporation, which produces wax-based anti-corrosion products to protect pipelines. (Courtesy of Emily Kennedy.)

Howard Patterson (1927–2000), an All-American swimmer in high school, went on to break records in the backstroke event at Michigan State College in 1946. In 1948, he became the first person from Saginaw to qualify for the US Olympic team. After serving his country in the Navy from 1945 to 1946 and as a commissioned officer in the Army from 1950 to 1953, he was employed with the State of Michigan for 35 years. (Author's collection.)

Glen A. Boissonneault (1917–1991), editor of the *Saginaw News*, is seen here busy at work behind stacks of books. Glen joined the paper as a reporter in 1946, fresh from earning a Purple Heart, five combat stars, and three Theater of War ribbons as an Air Force B-29 bombardier-navigator in World War II. He became editor of the *Saginaw News* in 1959. From 1966 until his retirement in 1976, he was editor of the *Flint Journal*. (Author's collection.)

Arnold Bronner (1917–1991), a Frankenmuth native and Arthur Hill graduate, began his career in 1936 as a teller at the Second National Bank and Trust Company. He served in the Army during World War II, earning three Bronze Battle Stars. In 1954, he served as president of the Great Lakes Machinery Movers, Inc., while working as an office manager for Stevens Van Lines. In 1958, he was named president of Stevens Van Lines. (Author's collection.)

www.arcadiapublishing.com

Discover books about the town where you grew up, the cities where your friends and families live, the town where your parents met, or even that retirement spot you've been dreaming about. Our Web site provides history lovers with exclusive deals, advanced notification about new titles, e-mail alerts of author events, and much more.

MADE IN THE USA

Arcadia Publishing, the leading local history publisher in the United States, is committed to making history accessible and meaningful through publishing books that celebrate and preserve the heritage of America's people and places. Consistent with our mission to preserve history on a local level, this book was printed in South Carolina on American-made paper and manufactured entirely in the United States.

This book carries the accredited Forest Stewardship Council (FSC) label and is printed on 100 percent FSC-certified paper. Products carrying the FSC label are independently certified to assure consumers that they come from forests that are managed to meet the social, economic, and ecological needs of present and future generations.

FSC
Mixed Sources
Product group from well-managed
forests and other controlled sources

Cert no. SW-COC-001530
www.fsc.org
© 1996 Forest Stewardship Council

Find Your Place in History.